HISTORIC GLENSHEEN

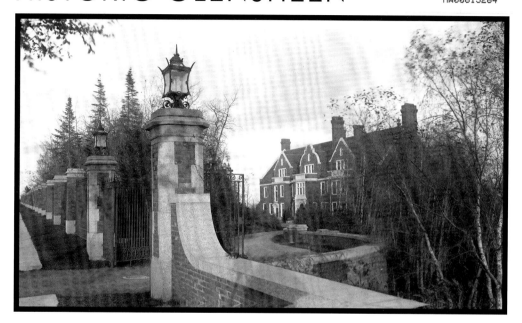

PHOTOGRAPHS FROM THE CONGDON ESTATE'S FIRST 25 YEARS

Text By Tony Dierckins

ZENITH CITY PRESS DULUTH, MINNESOTA

Zenith City Press
Duluth, Minnesota
218-310-6541
www.zenithcity.com

Historic Glensheen 1905–1930:
photographs from the Congdon estate's first 25 years

Design and Text by Tony Dierckins
Copyedit by Scott Pearson
Proofread by Heidi Bakk-Hansen,
Hollis Norman, and Suzanne Rauvola

Cover & Title page: Glensheen's west gate, c. 1909
Back cover top: Glensheen's living room, c. 1909
Back cover bottom: Tischer Creek, c. 1909
Contents page: Post of West Gate, c. 1909

Image credits listed on page 122

First Edition, May 2015

15 16 17 18 19 • 5 4 3 2 1

Softcover ISBN: 978-1-887317-42-9
Library of Congress Control Number: 2015931907

Printed in Brainerd, Minnesota, USA by Bang Printing

For the photographers,
known and unknown,
professional and amateur,
whose work graces these pages.

Special thanks to Scottie Gardonio,
Glensheen's creative director, for
her efforts gathering and editing
the photographs in this book, and
to Glensheen Historic Estate and its
director, Dan Hartman, for allowing
Zenith City Press access to these
images and permission to use them
throughout this book.

In gratitude, five percent of the
publisher's sales of this book directly
support Glensheen Historic Estate.

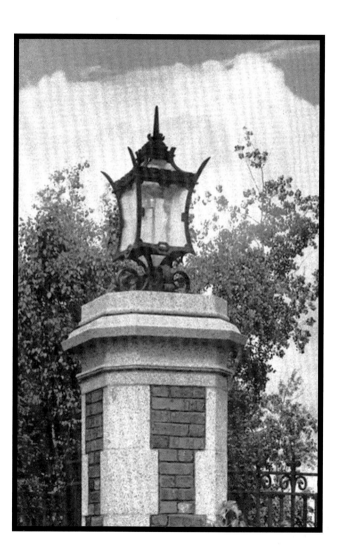

CONTENTS

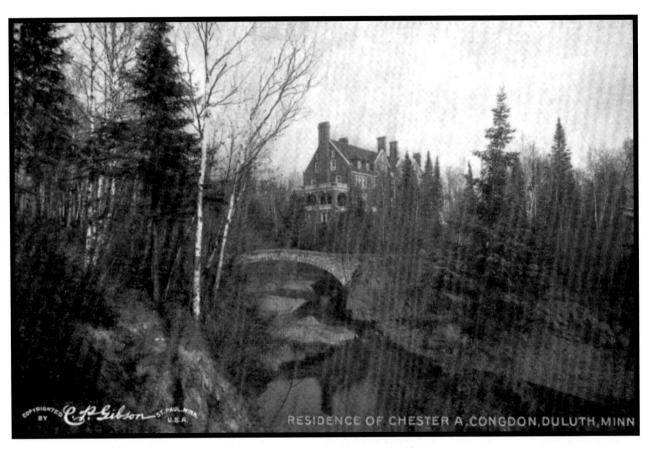

RESIDENCE OF CHESTER A. CONGDON, DULUTH, MINN

Like many of the photographers whose work appears herein, we do not know the name of the person who took the original photo that St. Paul's C. P. Gibson Company turned into this postcard, published c. 1910.

FOREWORD

Putting this book together was a treat, mostly because I was given a rare opportunity to view well over 150 images of Glensheen seen only by a handful of people during the past one hundred years—and Glensheen Historic Estate has generously allowed me to share them with you.

The vast majority of these images were captured by an unnamed photographer in 1909 to accompany an article by Clarence Johnston, Glensheen's architect, for the April 1910 edition of *Western Architect Magazine*. Seventeen photos made it into the magazine, but the Congdon family received dozens of prints from the shoot, and all that could be located are included herein.

This book also contains many other photos taken between 1905 and 1930. Some of these may be the work of Edward Congdon, Chester and Clara's second-oldest son, who was an avid photographer at the time—Glensheen was built with a darkroom adjacent to Edward's bedroom. A few may have been taken in 1914 by photographer E. A. Howard, who took portraits of Clara Congdon and her eldest daughter Marjorie in the house's library that year. Others could very well be the work of family or staff, including several photos taken in July 1918 discovered at Glensheen in February 2015 just months before this book's publication.

I also stumbled across a 1910 book titled *Duluth Trade News* at the Duluth Public Library. It contains an image of Glensheen's south façade (page 25) and one of stepping stones along Tischer Creek with Glensheen peaking out of the trees (page 105). These two images are the only full-sized photographs in this book Glensheen did not provide.

The quality of these photos is as varied as those who made them, and it appears that photographers both amateur and professional had the same problem their modern counterparts deal with to this day. With its grand southern exposures, Glensheen's interior is difficult to capture on film, and they were working with much more primitive equipment. Further, few made it into frames or albums. So not only do we lack precise dates for many of the photographs that are not part of the *Western Architect* collection, but nearly all of those images were found in less-than-ideal condition.

Because the negatives no longer exist (or have yet to be found), the images in this book are digital scans of prints—most over one hundred years old—many of which were faded, scratched, or otherwise blemished. Glensheen's Scottie Gardonio gathered the photographs and helped me edit them into printable images with a minimum of digital retouching. Enjoy them all. While they may not be a museum curator's dream, they are rare historic documents as well as priceless gifts from Glensheen Historic Estate to the Duluth community and beyond. The story they tell is remarkable.

— Tony Dierckins, March 2015

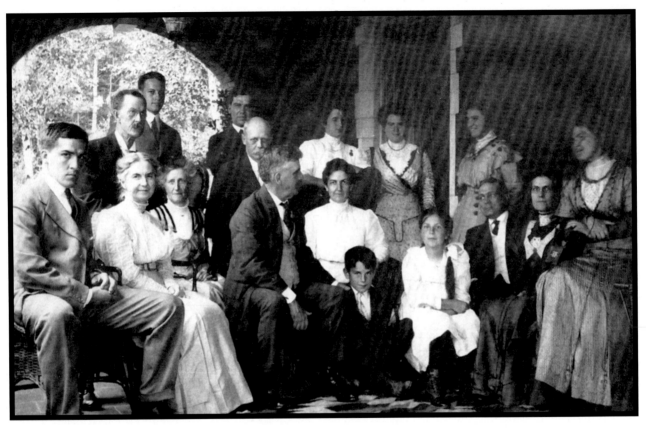

The Congdon family and some of their Bannister relatives gathered on Glensheen's west porch during the summer of 1909, shortly after the Congdons moved into Glensheen and before any of the children had wed and moved away. Clara sits second from left, just right of son Edward at the far left. Chester, also seated, faces right with his hand on youngest son Robert's shoulder. Youngest daughter Elisabeth sits just to the right of Robert, and standing behind her are her sisters Marjorie (l) and Helen (r). Cousin Alfred Bannister, who lived with the Congdons, stands tallest in the back row below the arch; Walter, the eldest Congdon son, stands right of Alfred.

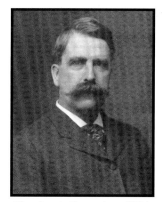

Chester A. Congdon, 1906.

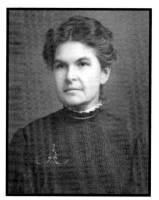

Clara H. Congdon, 1906.

A BRIEF HISTORY OF THE CONGDON FAMILY

Chester Adgate Congdon (1853–1916) first went to work at age fifteen in a lumberyard in Corning, New York, to support his mother and younger brother. His father had recently died of pneumonia, and three of his siblings had been claimed by scarlet fever. When he entered Syracuse University in 1871, he promised his mother they would all "revel in luxury some day…. We will be infinitely better off than the large majority…. I want to be better off than everybody else."

At Syracuse he met San Francisco native Clara Hesperia Bannister (1854–1950)—like him, the child of a Methodist minister—and together they graduated in 1875. Both planned to become educators, and after college Clara took a job teaching in a women's college in Ontario; Chester studied law and passed the New York

bar in 1877. After a brief, financially frustrating stint as a school principal in Chippewa Falls, Wisconsin, he was off to St. Paul, Minnesota, to practice law.

There he took a job as assistant to William Billson, the U.S. District Attorney for the State of Minnesota. A year later Billson left his post to move to Duluth, Minnesota, to begin a private practice. Congdon, meanwhile, married Clara in Syracuse and brought his bride west to St. Paul. Between 1882 and 1891, Clara gave birth to five children: Walter, Edward, Marjorie, Helen, and John. During this time Chester transitioned to private practice.

Congdon's work often brought him to Duluth, where he visited with Billson. In 1892 he accepted Billson's offer of a partnership and moved his family to Duluth. Shortly thereafter, John died of scarlet fever just days before his

second birthday. Chester and Clara kept their family growing, adding Elisabeth in 1894 and Robert in 1898. In 1896 Clara's recently orphaned nephew, Alfred Bannister, came to live with the Congdons. In 1896 the Congdons bought the "Redstone," a three-story Victorian masterpiece on East Superior Street designed by Duluth architect Oliver Traphagen and faced in red Lake Superior sandstone .

Chester enjoyed an early stroke of luck in the Zenith City. When Henry Oliver visited Duluth to hire Billson to oversee mining his company's Minnesota holdings, the senior partner was out of town. Congdon took the meeting instead; he and Oliver became fast friends, and Chester got the job. Oliver Mining would become the largest iron ore producer on Minnesota's Iron Range.

Working for Oliver, Congdon expanded and defended the company's interests on the Mesabi Iron Range. He also purchased Oliver Mining stock. In 1901 J. P. Morgan bought out John D. Rockefeller, Andrew Carnegie, and Oliver Mining to form United States Steel. In six short years the value of Congdon's stock had risen 555 percent; almost overnight Congdon had become one of the wealthiest men in Minnesota. He then partnered with Oliver and John Greenway to buy up Western Mesabi property that held silica-rich low-grade ore called taconite. After Greenway devised a way to remove the silica, they sold or leased the newly valuable property to mining companies. Meanwhile Congdon diversified, opening copper mines in Arizona and building an irrigation canal in Washington's Yakima Valley.

By 1904 the Congdons were indeed "better off than everybody else." Construction of Glensheen began in 1905 and took four years to finish. Most of the children, including cousin Alfred, were already off to boarding school and college when the estate was complete, but all would reside at Glensheen after they graduated and before they married. Most of the weddings were held at Glensheen.

While Glensheen was being built, Chester became interested in politics. The Republican served as the representative from Minnesota's fifty-first district from 1909 to 1913. In early 1916 Congdon was elected as a member of the National Republican Committee. Just days after Democrat Woodrow Wilson won the presidential election, Chester Congdon died of a pulmonary embolism.

Following the death of her father, Elisabeth Congdon dropped out of college to help her mother run the house. Clara and Elisabeth took over the estate's operations while Walter and Edward grabbed the reins of the family's varied business interests and investments. In 1921, after a series of gardeners came and went, Clara and Elisabeth found George Wyness, who worked for the Congdons the rest of his life. George was succeeded by his son Bob, who lived on the estate until February 2004. He died in October, 2004.

By 1930 the Congdon children were all married and had moved out of the house—except for Elisabeth. She never wed, but she did adopt two daughters. Clara Congdon died in 1950; Elisabeth died in 1977, after which the University of Minnesota Duluth became the estate's owner.

Clarence H. Johnston Sr.

CONSTRUCTION: 1905–1909

Chester and Clara Congdon took their time planning their new home. Clara had begun making notes in her diary in 1901. The next year they picked out a site about two miles east of downtown Duluth along London Road, roughly between 33rd and 35th Avenues East. Two creeks ran through the property, Tischer Creek (then called "Tischer's Creek") near its western border and Bent Brook roughly at its center.

The Congdons hired Clarence H. Johnston Sr., a prominent architect for the State of Minnesota, to design the family home. A few years earlier, Johnston had been appointed architect to the Board of Regents of the University of Minnesota, and he is credited with designing many of the university's buildings on all of its campuses. At the Congdons' request, Johnston designed a manor that would have looked right at home in the English countryside. The Congdons named the estate "Glensheen" after, it is often repeated, the deep ravines Tischer Creek had carved along its banks and the sheen of its glimmering waters (and perhaps for Sheen, England, the ancestral home of Chester's family).

It took from June 1905 until February 1909 before construction supervisor John Bush would write in his project diary, "end of house work." The entire project—including the main house, four greenhouses, a gardener's cottage, a formal garden, a flower garden, a vegetable garden, a carriage house, a boathouse and pier, a tennis court, a bowling lawn, a private water reservoir, and several rustic bridges—cost $864,000, more than $22 million today.

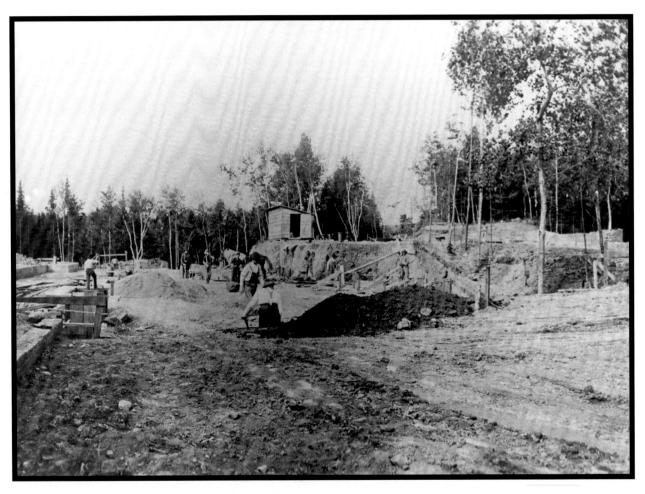

Construction began June 15, 1905. The work during that summer focused on the grounds,
raising road beds, digging drainage trenches, and laying lines for water, electricity, gas, and telephone.

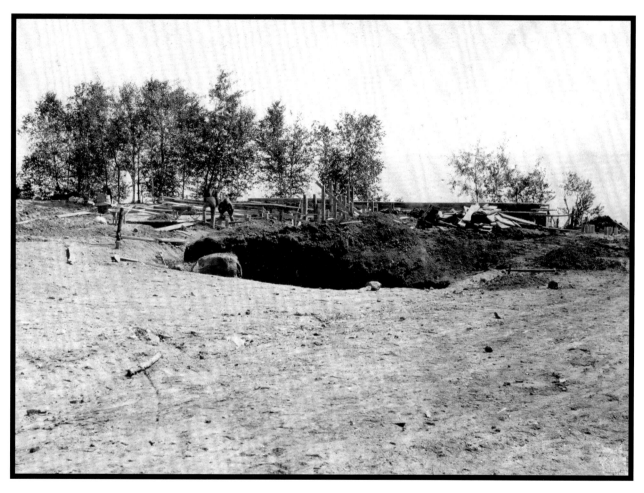

Looking south toward Lake Superior, 1905: the property was completely cleared of vegetation;
all of the trees and plants on the estate today were planted while the house was being constructed.

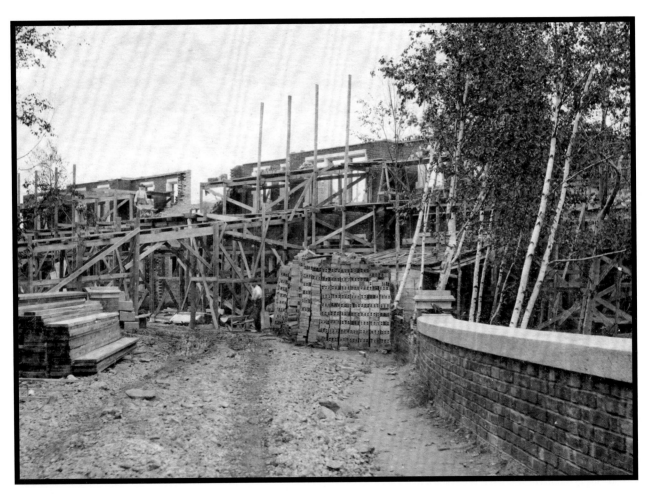

By the end of 1905, the ground floor's exterior walls were in place when work stopped due to cold and snow. From April to October 1906, the estate's main house, carriage house, and gardener's cottage were framed.

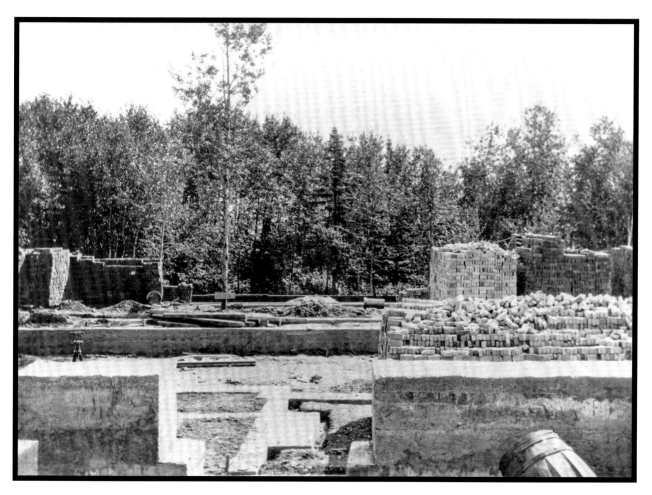

Bricks await installation in 1906. The short concrete walls are the foundations
of the main house, and the ground shown in the photo is the mansion's basement floor.

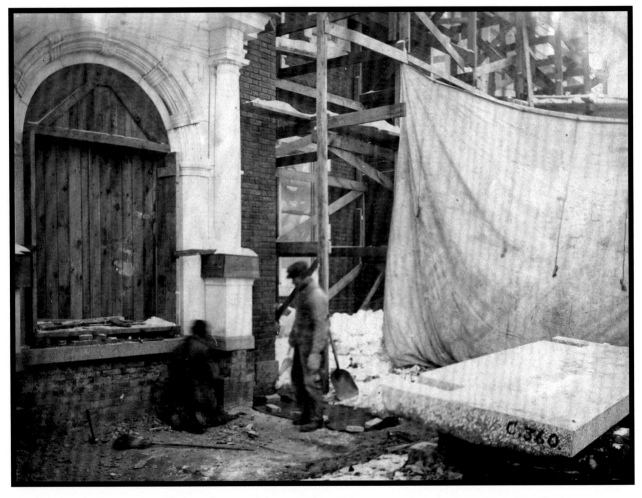

Workers prepare to install the front steps on January 10, 1907.

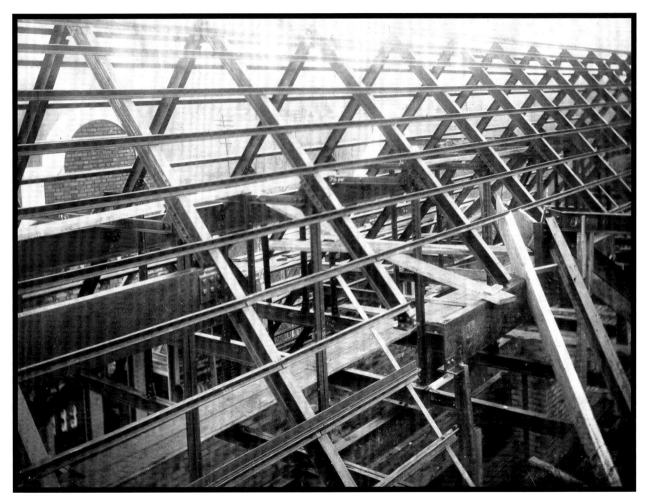

A rare look at Glensheen's steel framework, shown here in the roof supports, 1906. The roof was installed in March 1907.

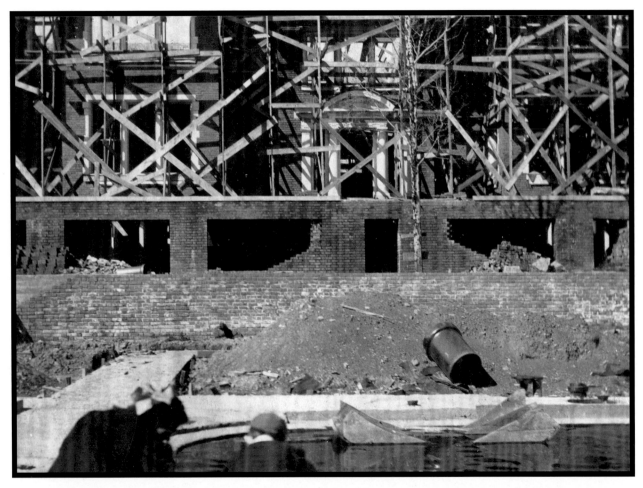

Progress on the south façade can be seen in spring 1906. That is likely nine-year-old Robert Congdon and one of his sisters with their backs to the camera. His brother Edward may have taken this and other construction photos.

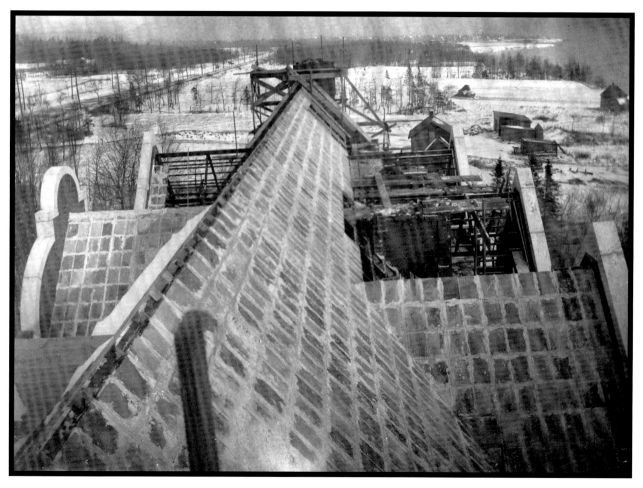

Several small temporary outbuildings were also constructed to store tools and expensive building materials, as seen in this view from the top of the house during roofing in March 1907.

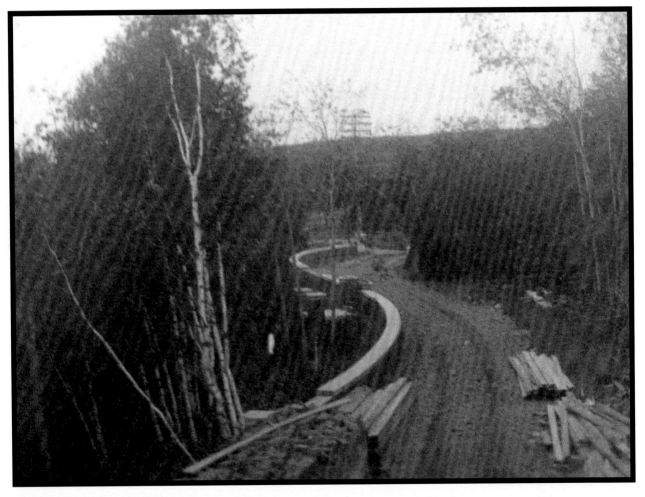

Construction of the winding path leading from Glensheen's west gate to the front of the house was well under way in 1907.

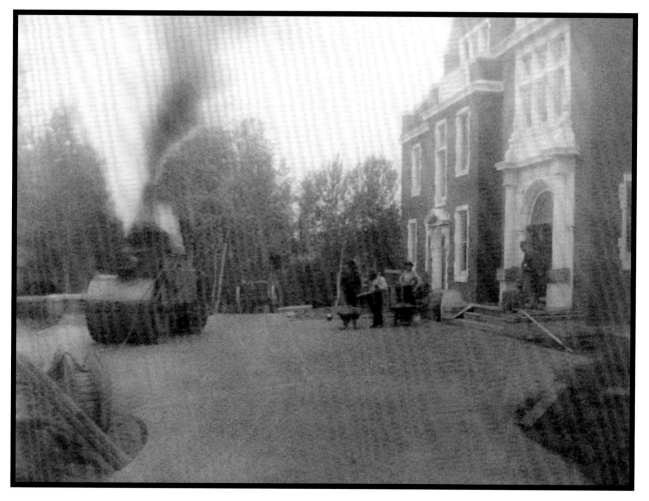

A steam roller flattens the asphalt apron of the driveway in front of Glensheen's north façade in 1907.

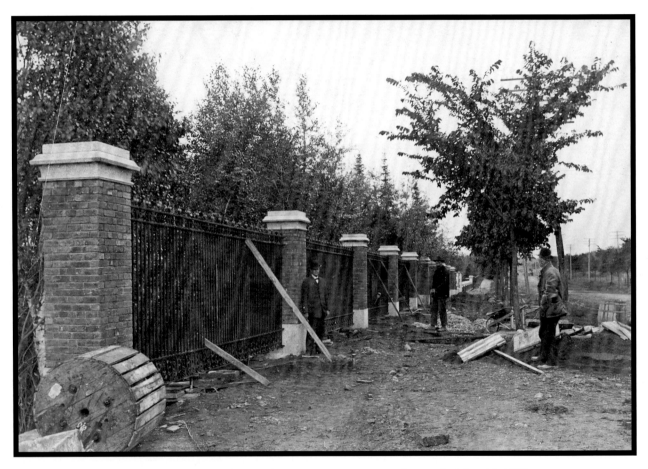

Glensheen's fence along London Road under construction on October 10, 1907.

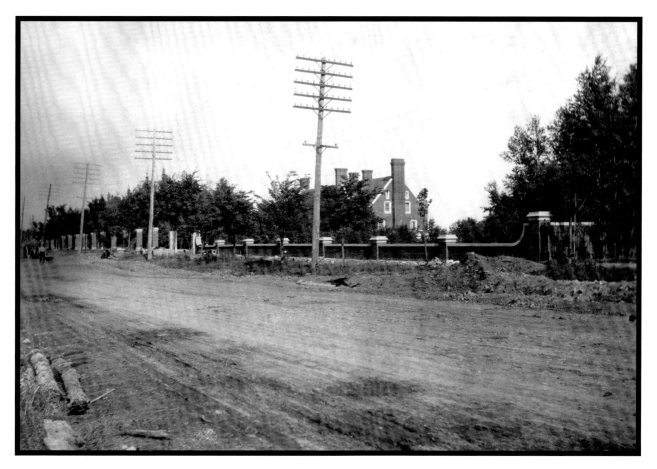

Along London Road at Glensheen's western border, 1907.

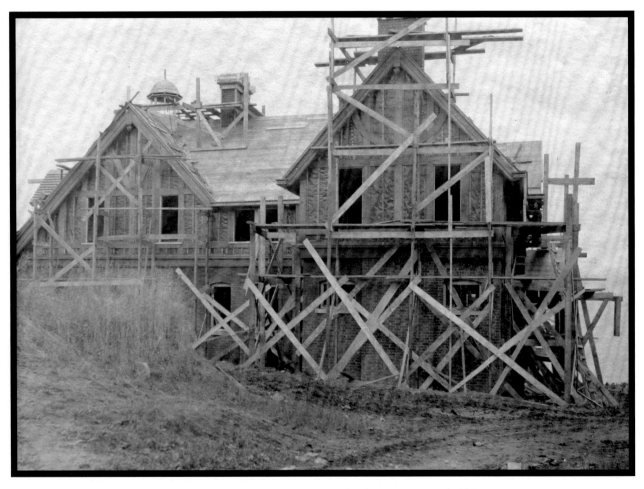

The carriage house under construction in the summer of 1906.

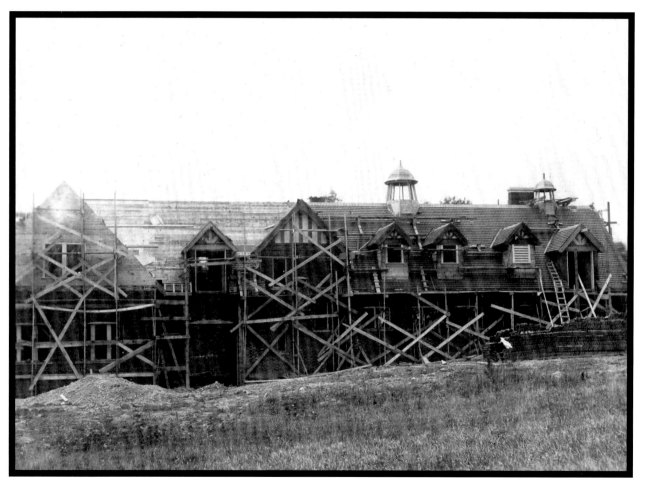

The eastern façade of the carriage house under construction in the summer of 1906.

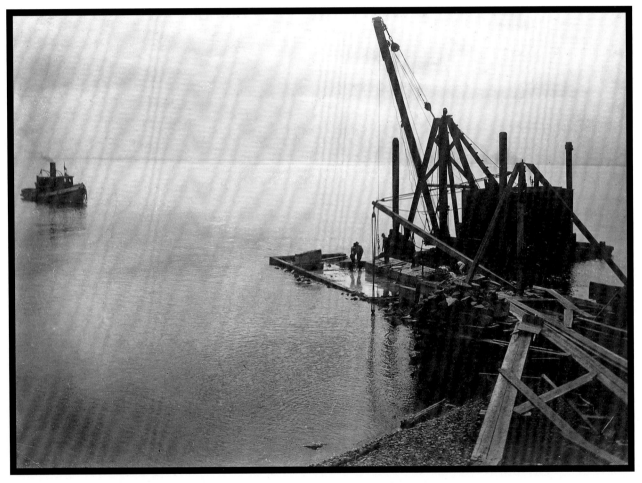

The boathouse and pier under construction in 1907. The brownstone used to construct
Glensheen's boathouse came from Ingall's Quarry in Duluth's Fond du Lac neighborhood.

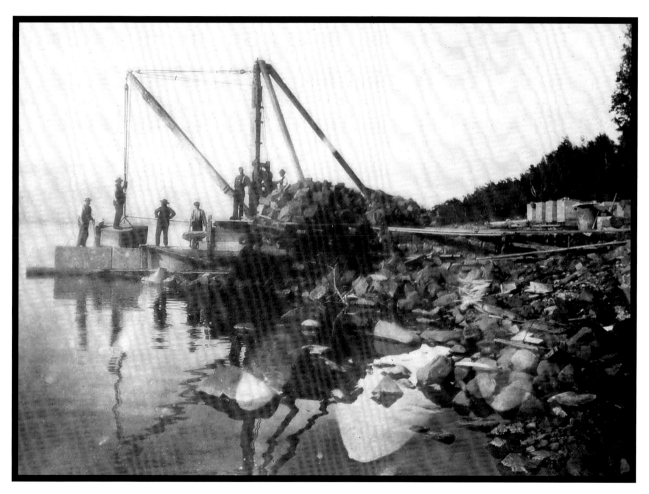

Precast concrete slabs are set into place on top of
timber-framed cribbing filled with rock to create the L-shaped pier.

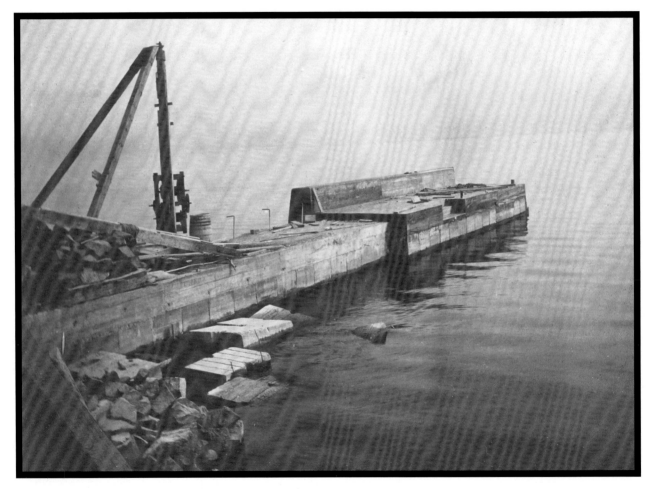

The pier under construction in 1907.

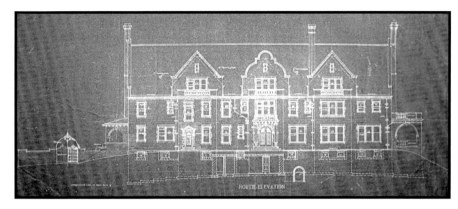

Architect Clarence Johnston's mechanical drawing for Glensheen's north elevation.

EXTERIOR VIEWS

Glensheen's Jacobean Revival design mimics aspects of buildings constructed during the late English Renaissance, 1603–1650 (some experts consider Glensheen's design Jacobethan Revival, which also contains elements from the Elizabethan period, 1508–1603). Not only was the style a popular architectural trend in 1905, but it reflected Clara and Chester's English heritage.

Glensheen's application for the National Register of Historic Places describes the house as a "two-and-one-half-story Jacobethan Revival dwelling made of reinforced concrete with reddish-brown Flemish bond brick walls trimmed in Vermont granite. It is built into a hillside so the south elevation, which faces Lake Superior, is terraced and features an elevated basement…. The primary entrance, part of a two-story projection, is centered in the north wall. A pair of paneled oak doors are set in a semicircular granite arch…. An arcaded porch with balustrade extending the width of the west end of the house overlooks Tischer Creek." The north side or front of the house is crowned with two traditional triangular gables centered on either side of a Flemish gable.

The south side of the house has three central gables flanked by four dormer windows, two on either side. Both the east and west gables include balustraded balconies accessible from bedrooms on the third floor. The central southern entrance is "flanked by battered Tuscan columns, deeply recessed leaded art glass sidelights, and pilasters, and features a curved pediment with dentils." The gable roof—framed, like the rest of the house, with steel beams—is tiled with terra cotta shingles.

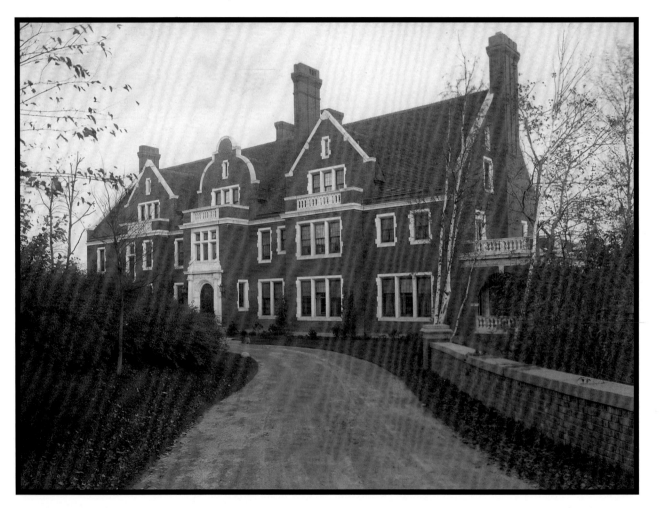

Entering the estate from the west gate, c. 1909.

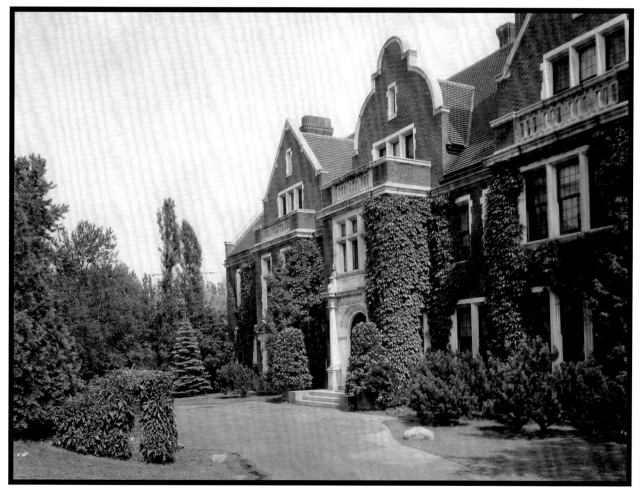

Glensheen's north façade, c. 1930; note the growth of the shrubs twenty years after the picture on the facing page.

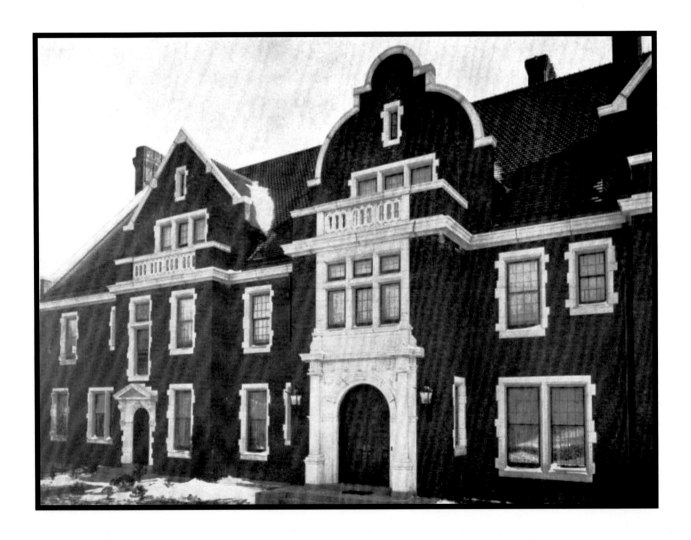

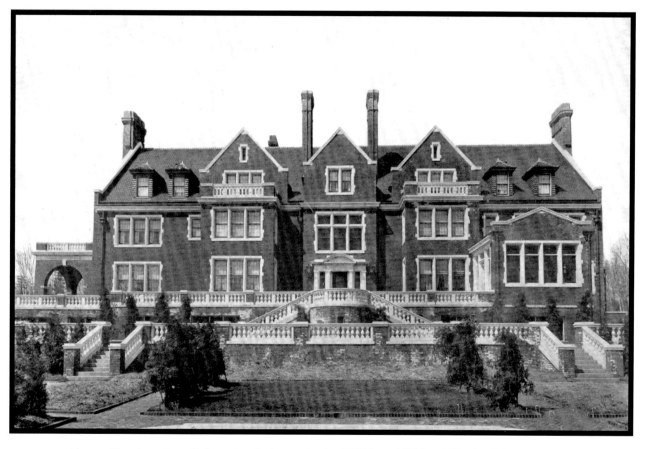

Above: Glensheen's south façade, photographed c. 1909 for a 1910 book titled *Duluth Trade News*.

Opposite: Glensheen's front façade, c. 1910.

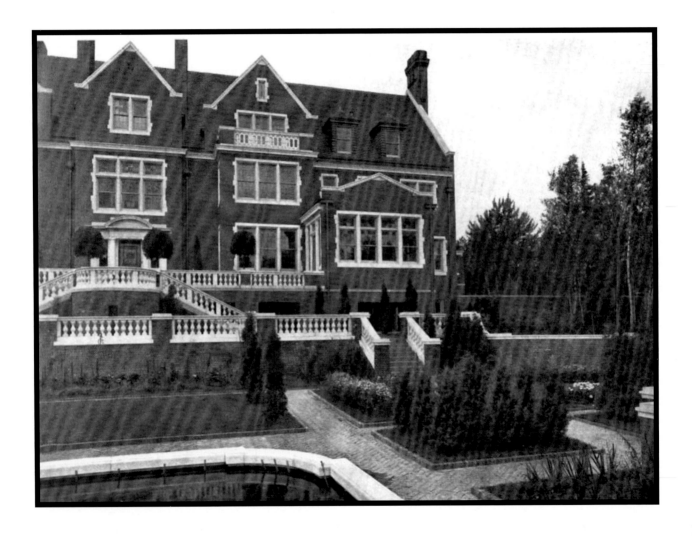

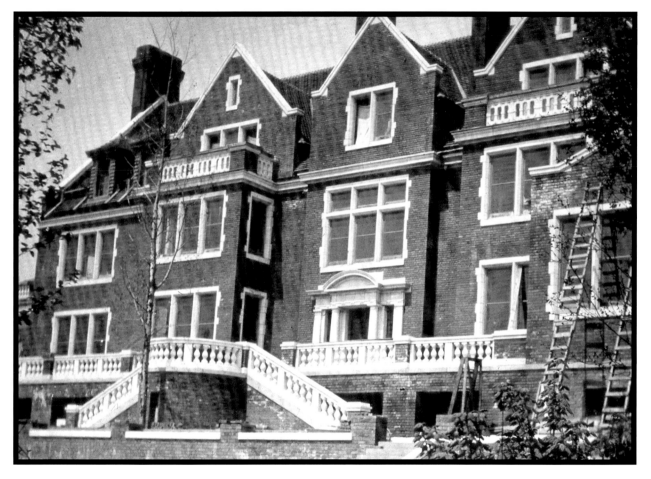

Above: Glensheen's south façade, likely 1908. Opposite: Glensheen's south façade, c. 1909.

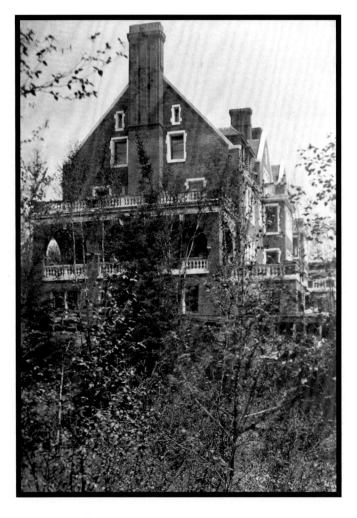

Glensheen's west façade as seen from Tischer Creek, likely in 1908.

The grand porch off the living room was a favorite spot of Chester's and his daughter Elisabeth.

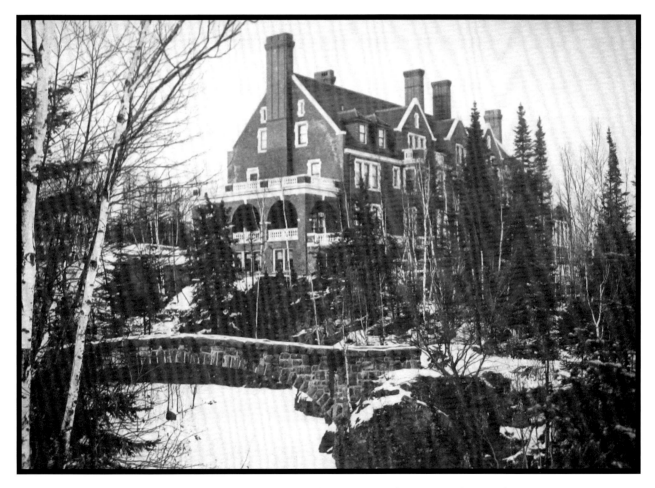

The main house and the stone arch bridge of Tischer Creek from the southwest, winter c. 1909.

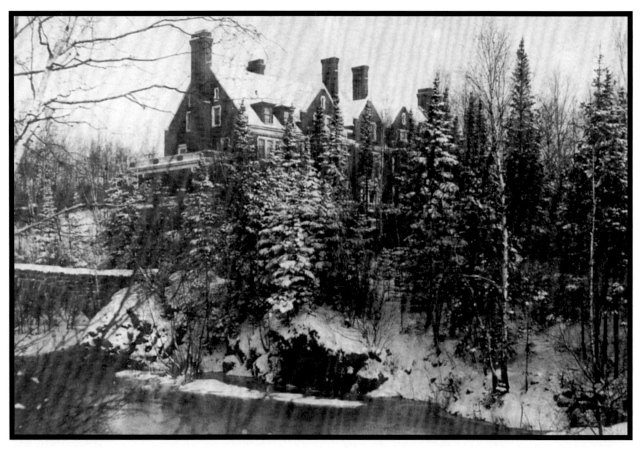

A view of Glensheen and Tischer Creek from the southwest, winter, c. 1910.

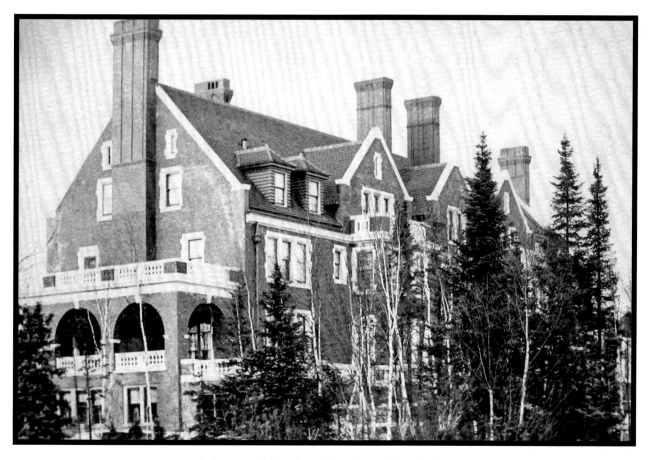

A close-up of Glensheen from the southwest, 1911.

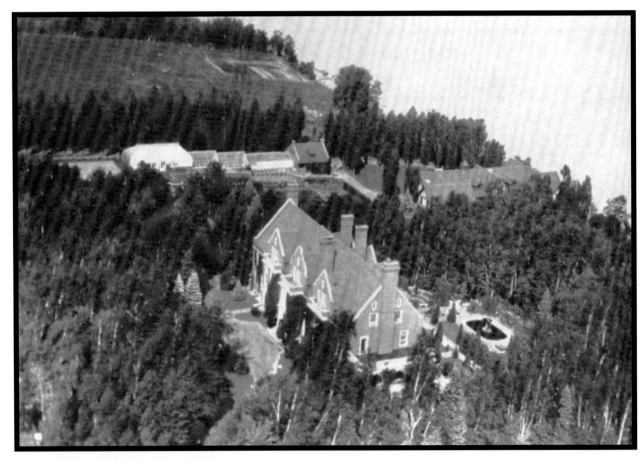

An aerial view of Glensheen, year unknown; the photo was taken sometime after the summer of 1913, when the fountain carved by George Thrana was installed in the formal garden.

An advertisement for the William A. French Furniture Co.

INTERIOR VIEWS

Clarence Johnston's interior design for Glensheen is a lesson in the balance of public rooms, private rooms, and service rooms (see page 118). The Congdons selected St. Paul interior design firm William A. French, which executed a Beaux Arts-Style design throughout much of the house. French in turn hired celebrated designer John S. Bradstreet, who used Arts-and-Crafts-Style elements in the first-floor smoking and breakfast rooms and throughout each room on the southerly side of the 3rd floor.

The first floor primarily serves as a public space for entertaining. It contains a reception room, library, living room, dining room, breakfast room, and smoking room, which doubled as Chester's den. The first floor also includes a kitchen, pantry, butler's pantry, sewing room, and small dining room for the staff.

The second floor held the bedrooms of Chester and Clara, their daughters, unmarried female guests, and the female household staff. (Most of the male staff had quarters in the carriage house.) The third floor—the domain of the Congdons' sons and Clara's orphaned nephew Alfred Bannister—contained the boys' bedrooms, a guest room for married couples, and an infirmary.

The lower level was primarily utilitarian, with a little fun for the family thrown in. The Congdons were limited to the billiard room, the recreation room, and a wing off the recreation room the Congdons called the "Little Museum." They also utilized space adjacent to the central staircase as the "toy room." The rest of the lower level held a boiler room, a humidification system, a wood room, a milk room, a laundry, and the butler's living quarters.

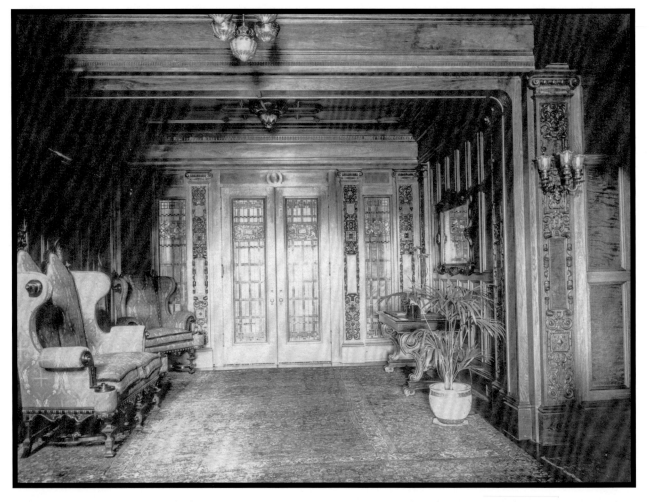

Glensheen's front door, from inside the main entry, c. 1909.

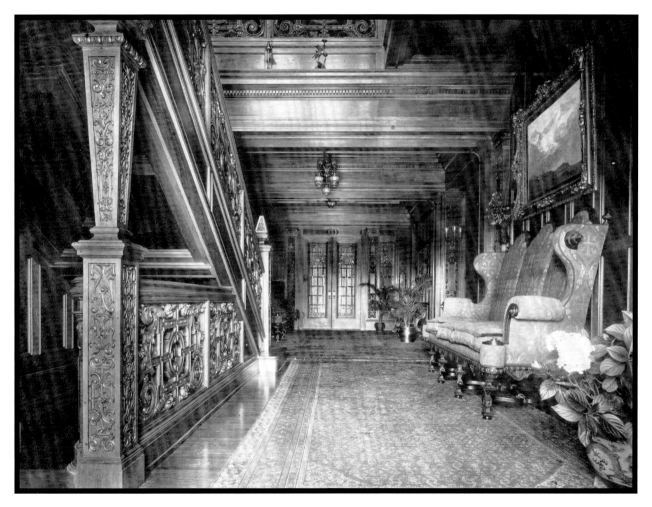

View from the back door to the front door adjacent to the grand staircase, c. 1909.

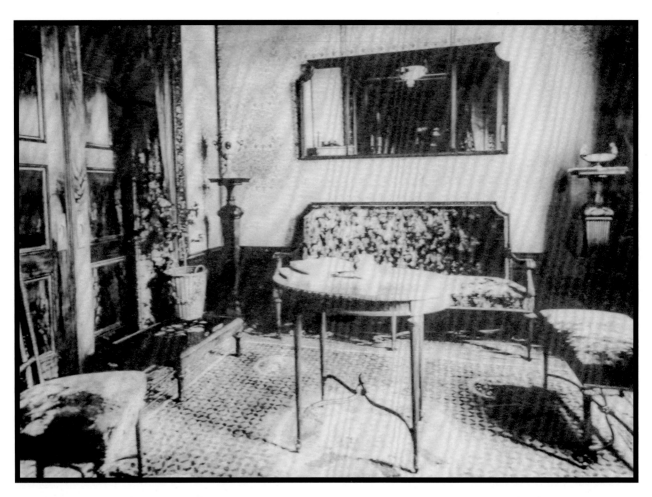

The first floor reception room, year unknown (likely sometime between 1909 and 1914).

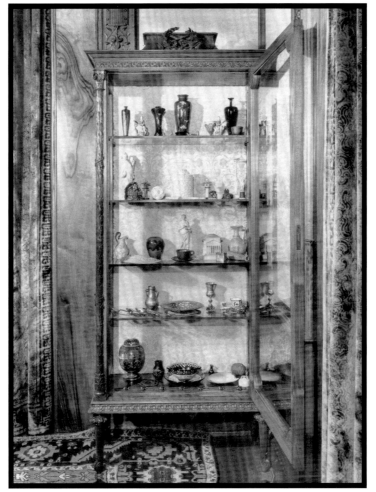

This curio cabinet, as seen in 1909, adorns Glensheen's reception room adjacent to the front door.

The Congdon's filled several such cabinets with mementos acquired during their travels abroad.

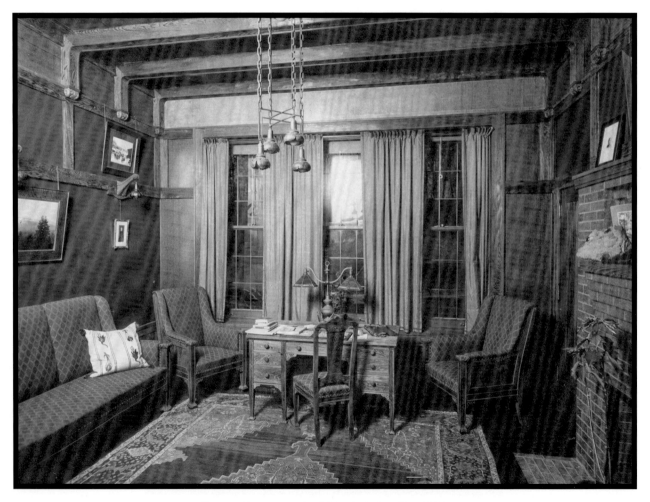

The smoking room, aka "Chester's Den," c. 1909.

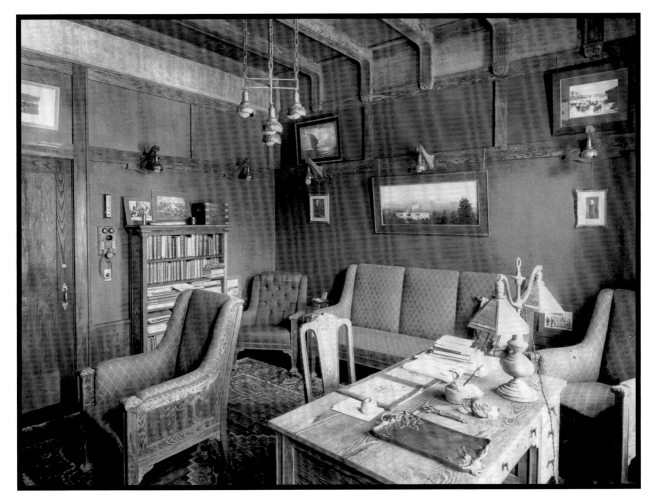

The smoking room, c. 1909.

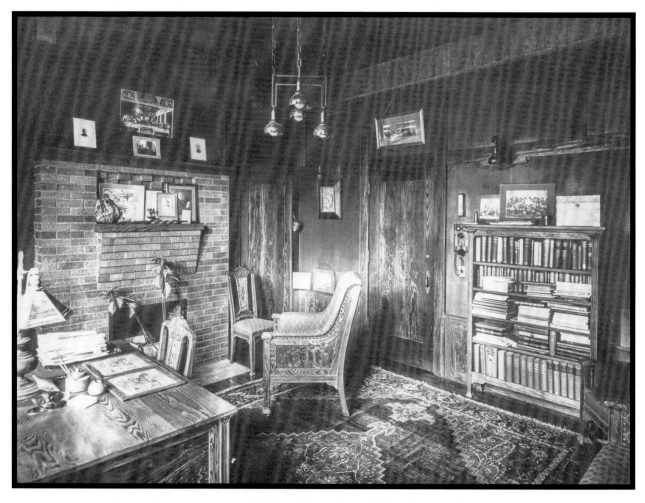

The smoking room, c. 1909.

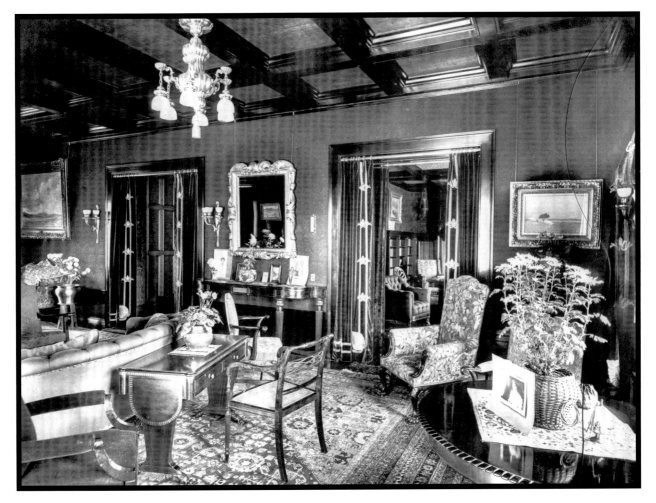

The living room, c. 1909.

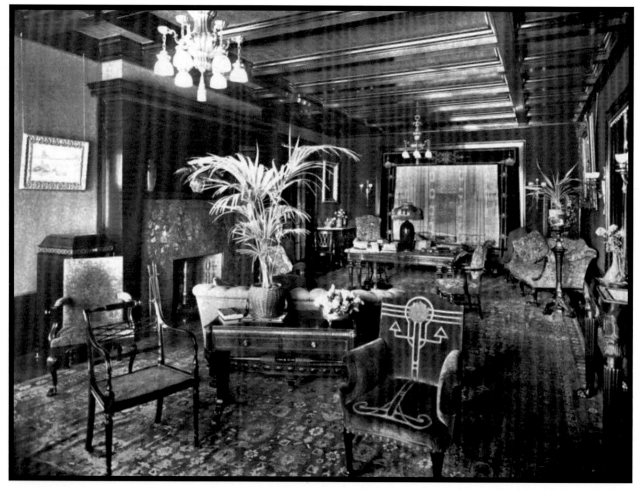

The living room, c. 1909.

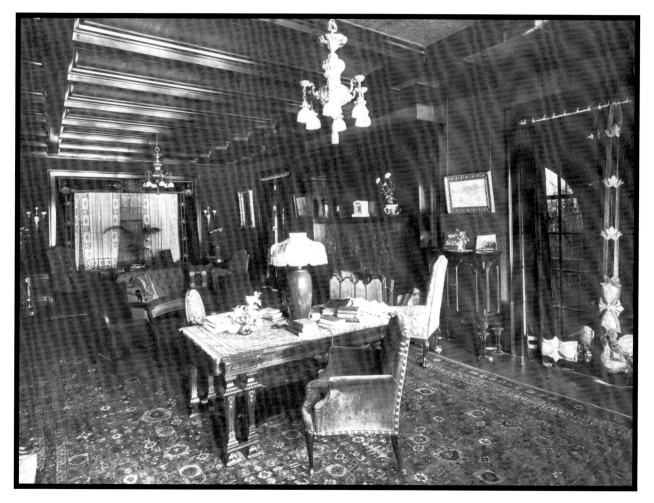

The living room, c. 1909.

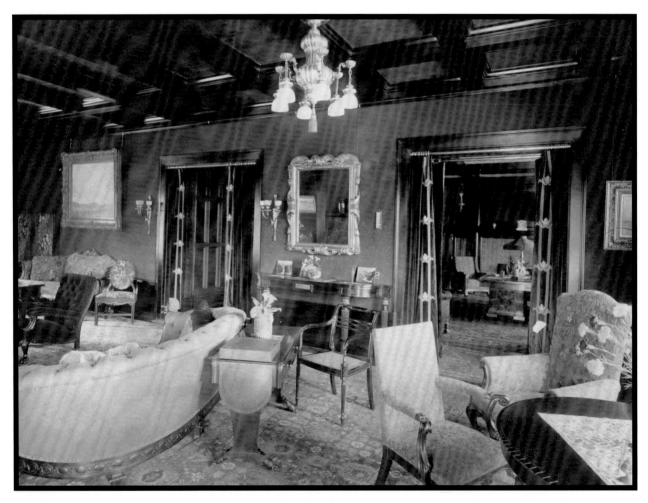

The living room, likely 1914.

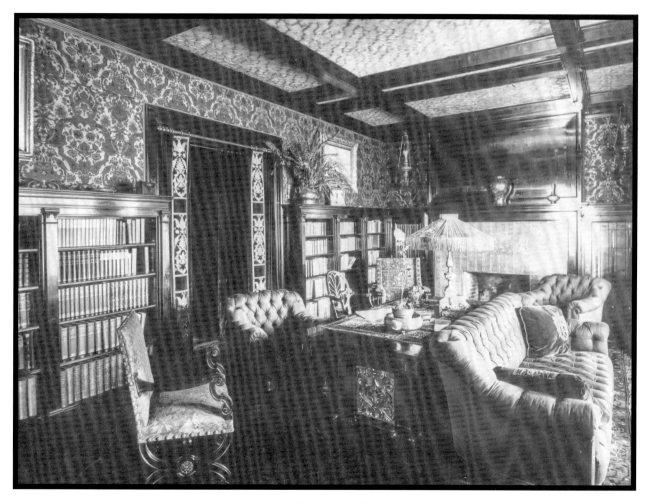

The library, c. 1909.

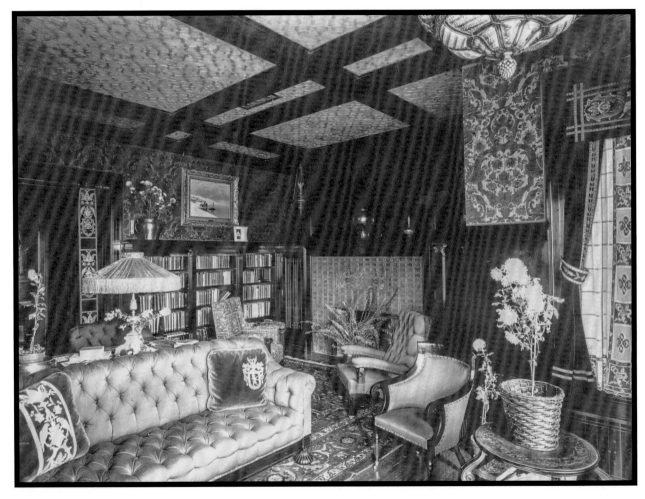

The library, c. 1909.

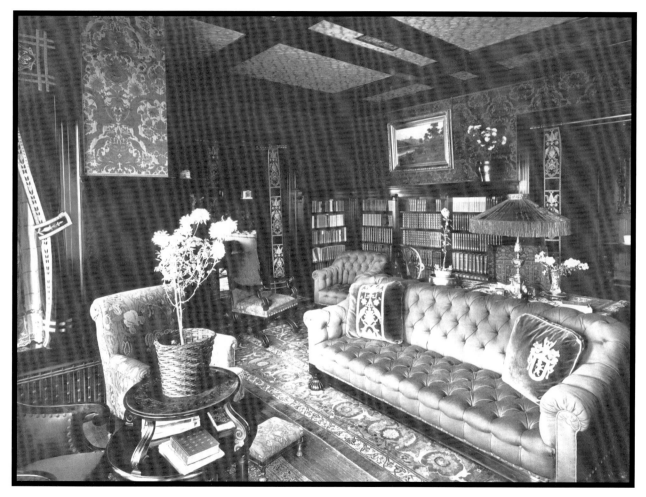

The library, c. 1909.

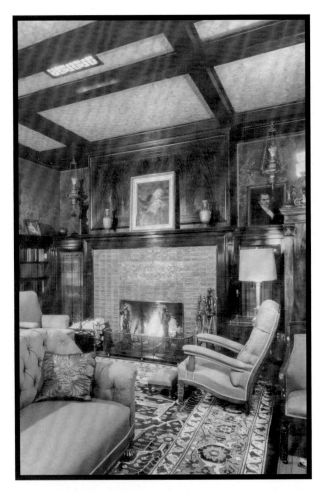

The library's fireplace, year unknown (likely 1914).

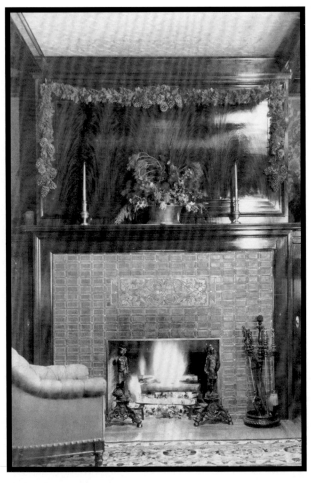

The library's fireplace decorated for Christmas, c. 1910.

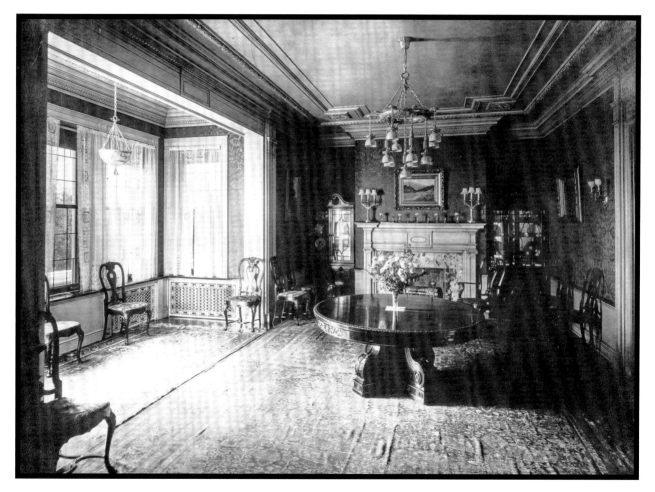

The dining room, c. 1909, showing the bay window with southern exposure.

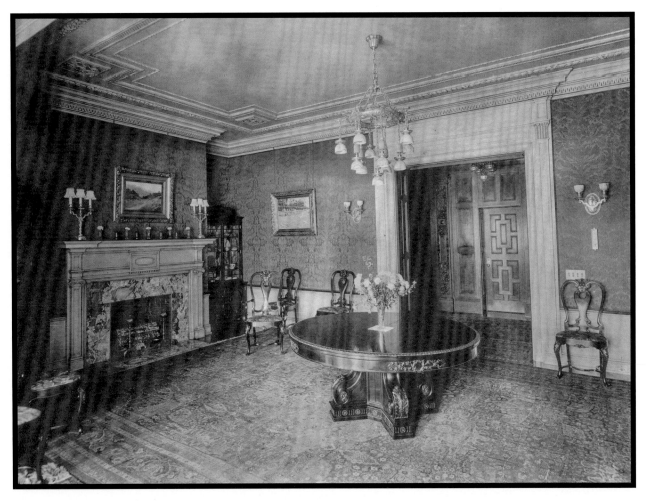

The dining room, c. 1909; the table has several leaves and can extend nearly the entire length of the room.

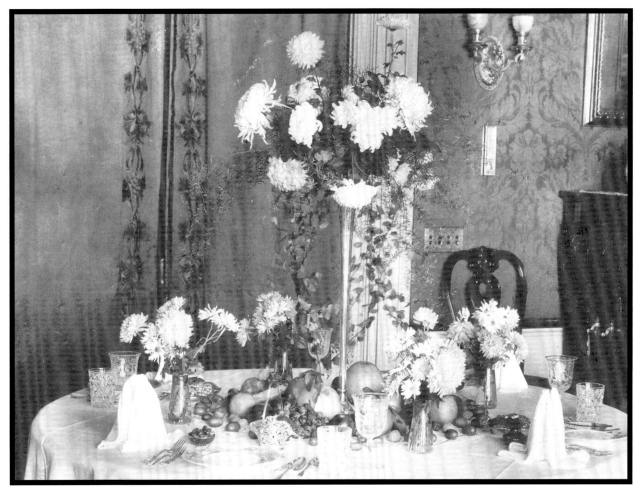

The Congdons' dining room table dressed for service, year unknown (likely between 1909 and 1914).

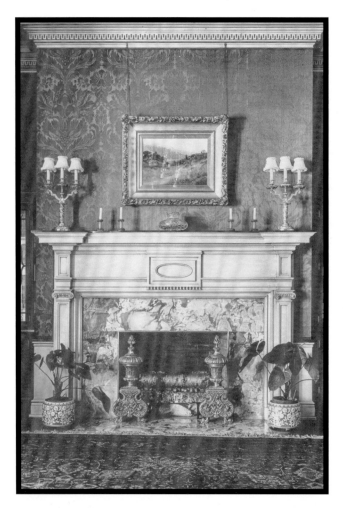

The dining room's fireplace, year unknown (likely 1914).

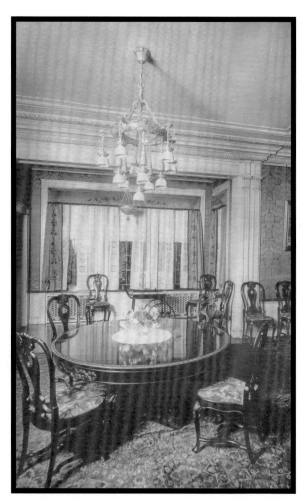

The dining room table, year unknown (likely 1914).

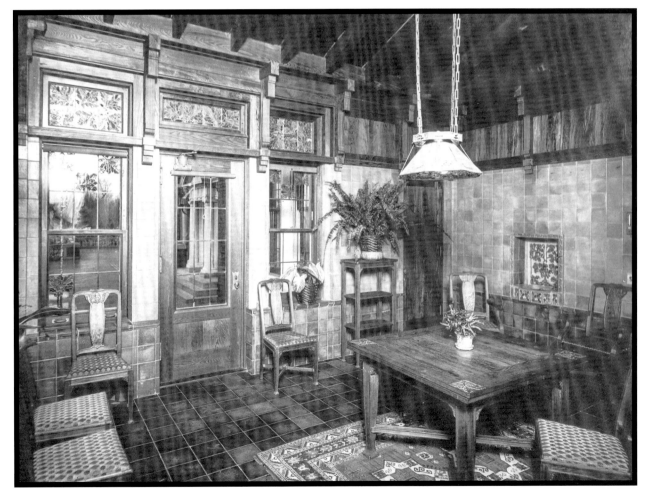

The breakfast room, c. 1909.

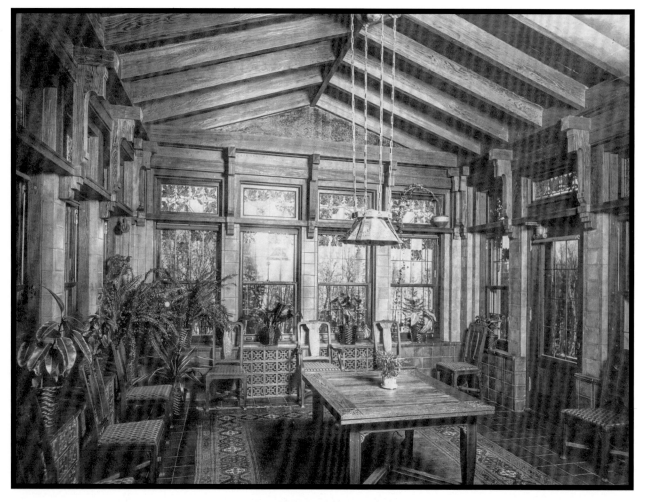

The breakfast room, c. 1909.

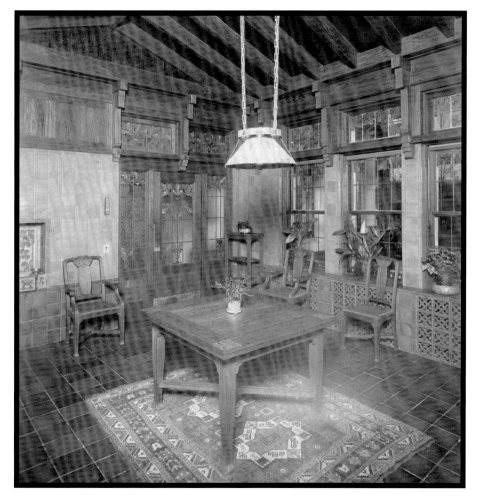

The breakfast room, c. 1909.

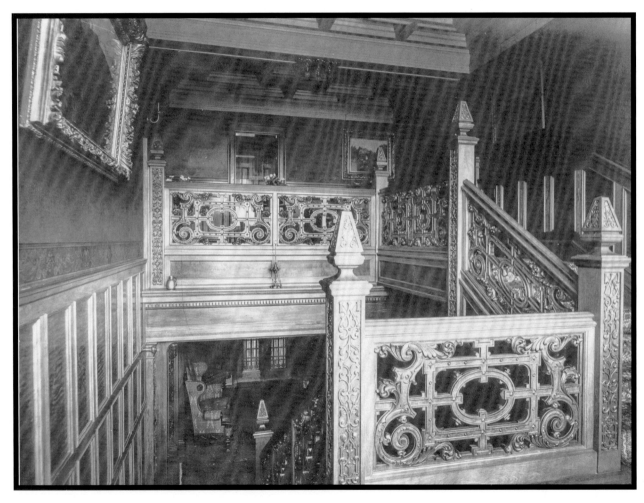

The central staircase from the first to the second floor, c. 1909.

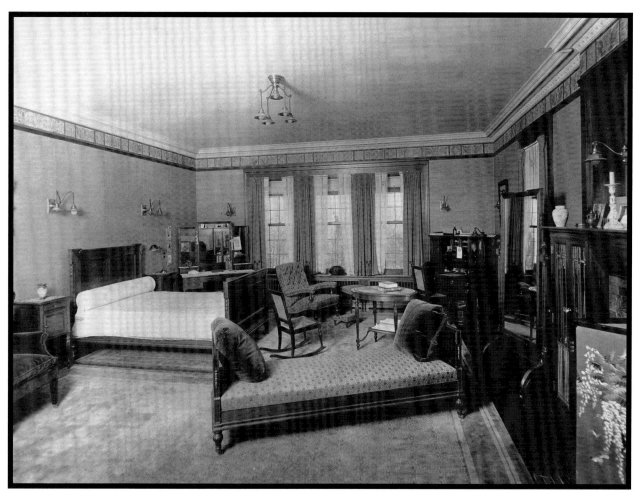

The master bedroom,1909; the suite includes a dressing room, master bath, and an additional sleeping chamber.

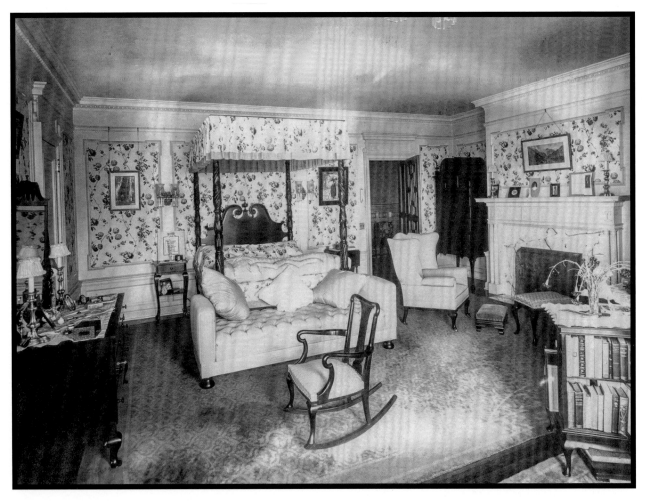

Bedroom of Marjorie Congdon (1887–1971), c. 1909. Marjorie moved out when she married Harry Chittendon Dudley in 1917.

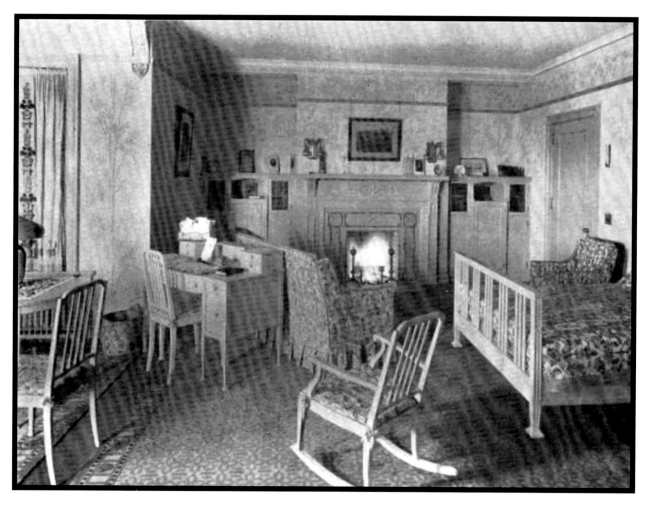

Bedroom of Helen Clara Congdon (1889–1966),1909. Helen moved out when she married Hugh D'Autremont in 1919.

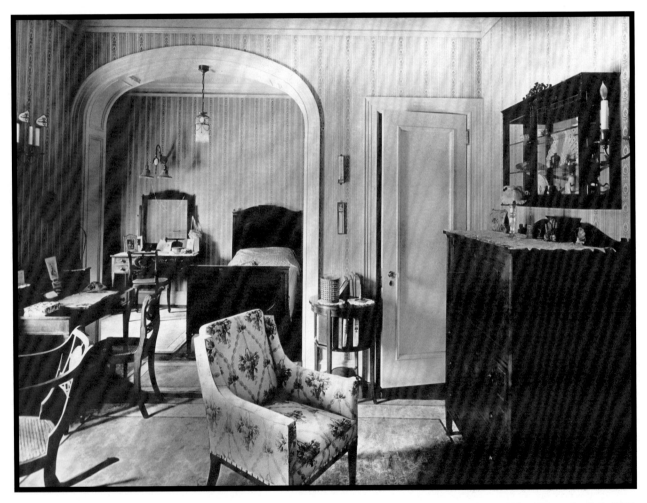

Bedroom of Elisabeth Mannering Congdon (1894–1977), c. 1909. Elisabeth lived at Glensheen from 1908 until her death in 1977.

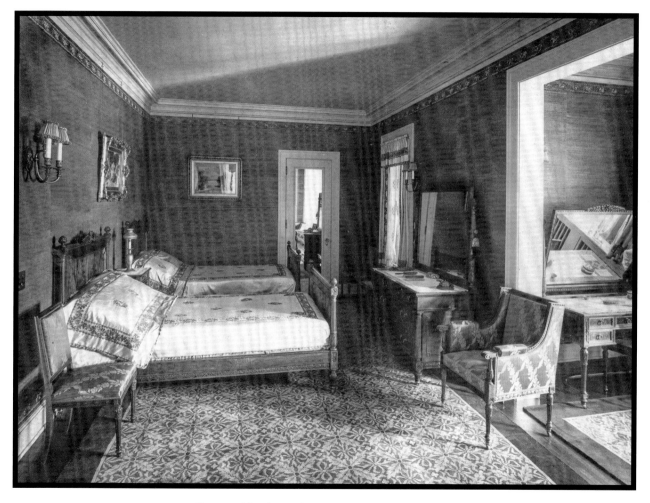

The guest bedroom for unmarried women, c. 1909.

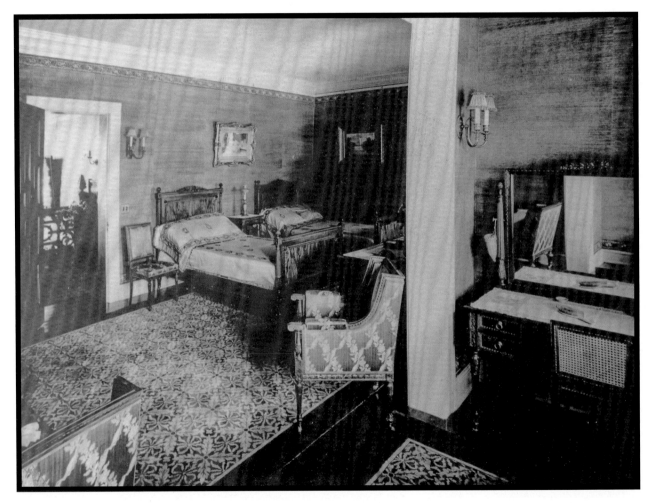

The guest bedroom for unmarried women, c. 1909.

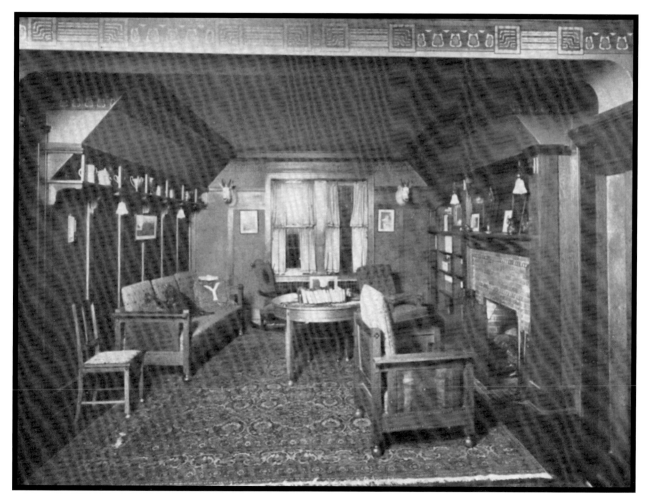

The third floor smoking room, aka the "boys' lounge," c. 1909.

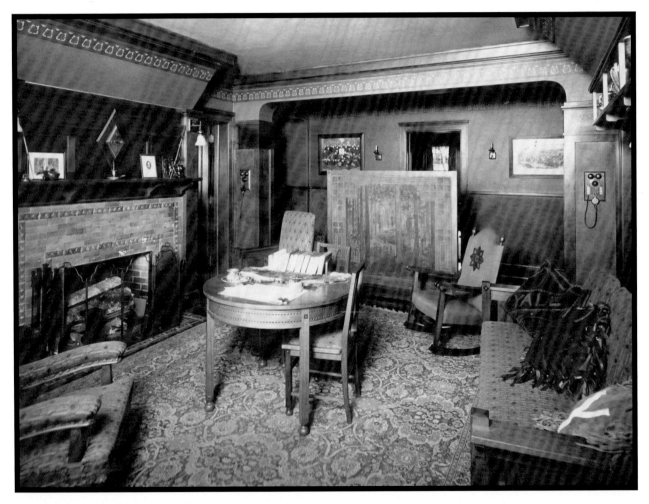

The third floor smoking room, c. 1909.

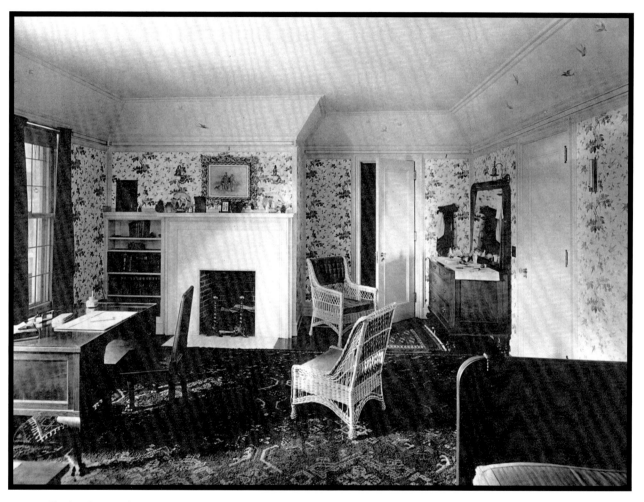

The bedroom of Robert Congdon (1898–1967). Robert moved out when he married Dorothy Moore in 1923.

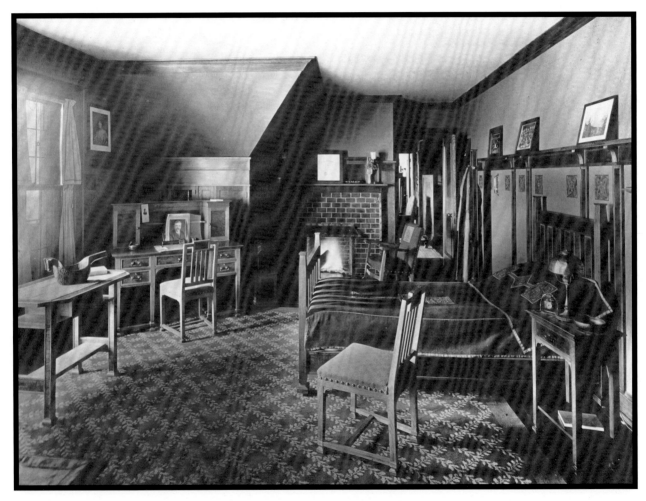

The bedroom of Edward Chester Congdon (1885–1940), c. 1909.

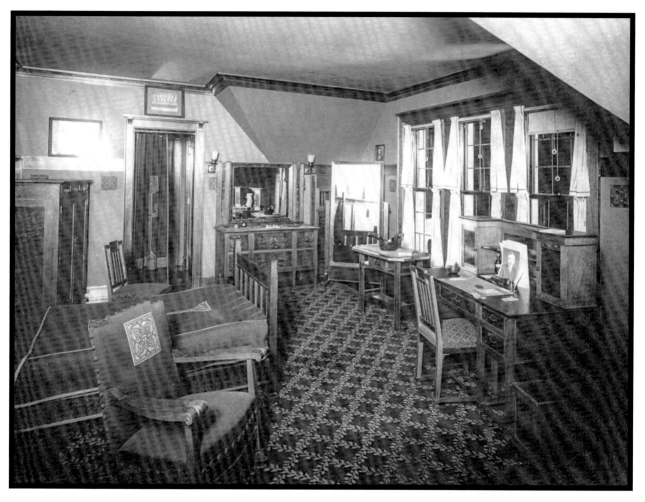

Edward's bedroom, c. 1909. Edward moved out when he married Dorothy House in 1920.

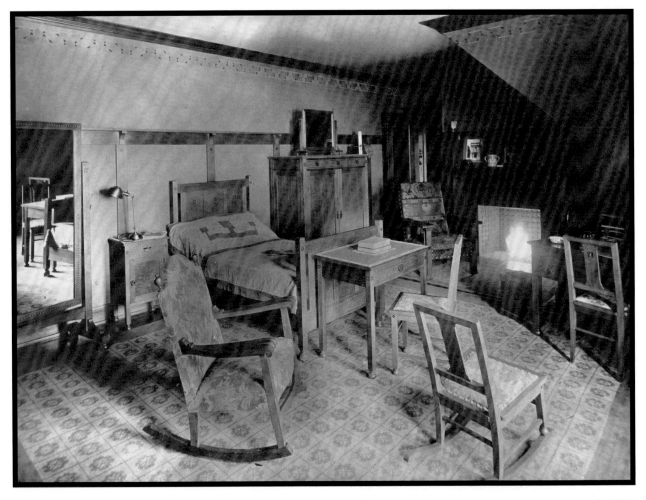

The bedroom of Walter Bannister Congdon (1882–1949), c. 1909; Walter moved out when he married Jessie Hartley in 1914.

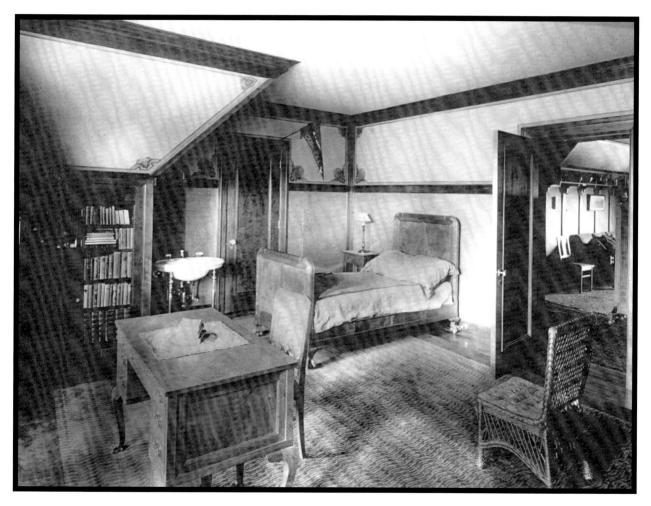

The bedroom of Alfred Bannister (1890–1952), c. 1909. Alfred moved out when he married Helen Wannebo in 1931.

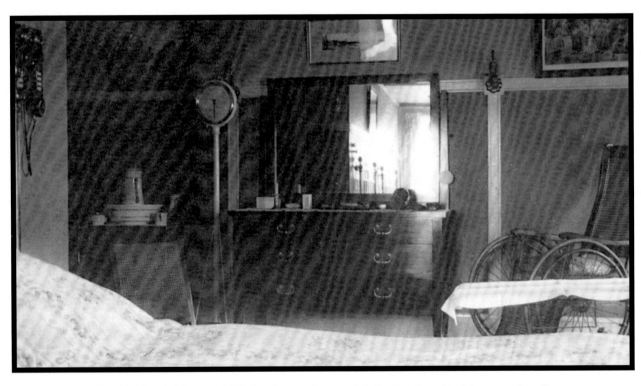

The third floor's infirmary, 1918. Family members and staff alike stayed in this room when ill.

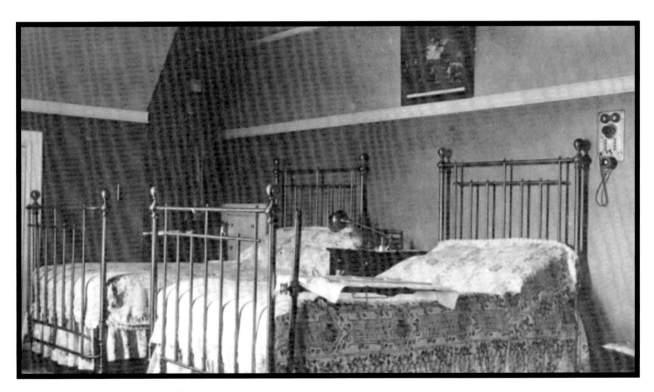

The third floor's infirmary, 1918. The room was also used as an extra guest room when needed—if no one was sick.

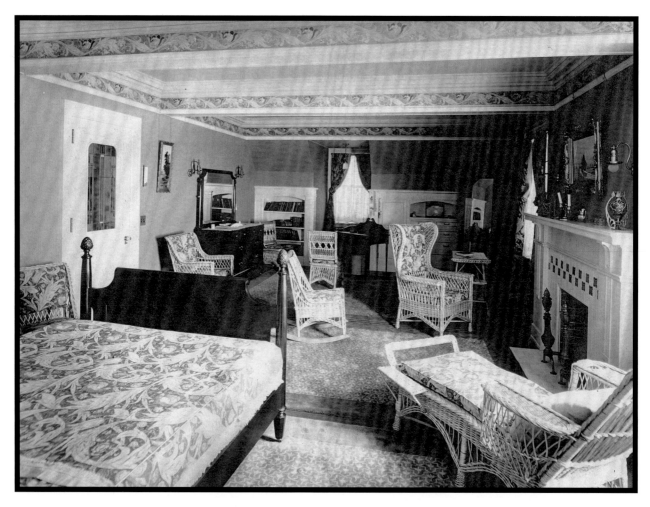

The guest room for married couples, c. 1909.

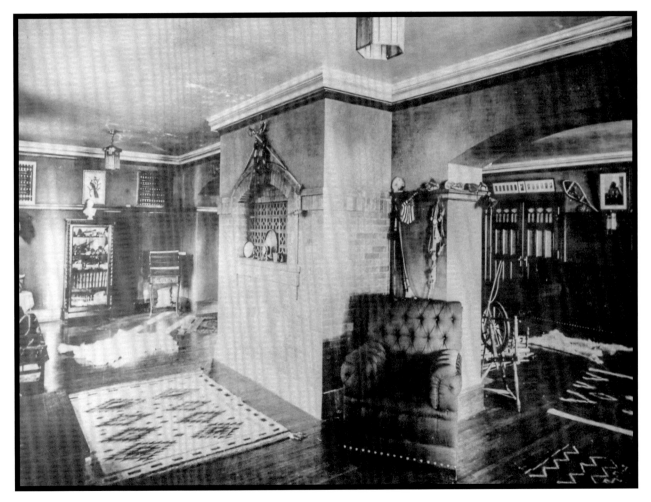

The lower level recreation room, year unknown (likely between 1910 and 1914).

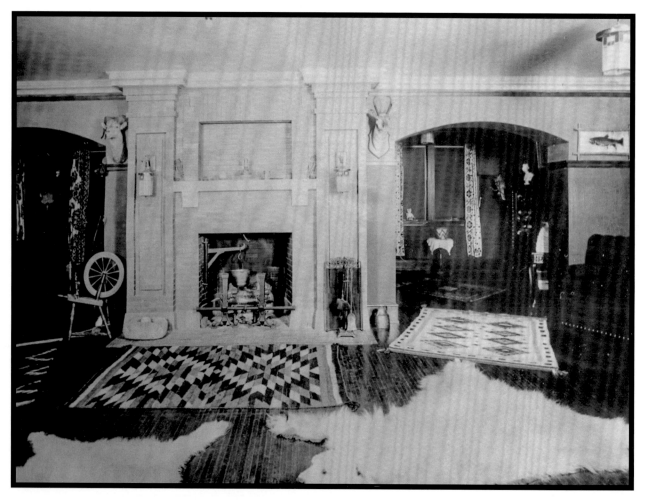

The lower level recreation room, year unknown (likely between 1910 and 1914).

Charles W. Leavitt

THE ESTATE GROUNDS

To landscape their twenty-two-acre estate, the Congdons hired arguably the best landscape architect in the nation. Charles W. Leavitt, described by a New York publisher as a "rare combination of engineer, artist, and diplomat," founded the first landscape architecture program at Columbia University. At Glensheen he would transform the property's clay-packed soil into a fully functioning, nearly self-sustaining estate. (See map on page 120.)

Leavitt had help from Anthony U. Morell and Arthur F. Nichols, Minnesota's foremost landscape architects. The Minneapolis firm would leave its mark throughout Duluth, designing Congdon Park (built on land donated by Chester), the stone bridges of Seven Bridges Road, and the Lester River Bridge as London Road turns into Congdon Boulevard (also built on land donated by Chester).

At Glensheen, Morell and Nichols executed Leavitt's plans, plotting the locations of the outbuildings and pasture land for the Congdons' horses and dairy cows; creating both a long, formal tree-lined entry on the east side of the estate and a short winding driveway that leads from the west side to the house's front door; laying out formal, flower, and vegetable gardens; building a path system with rustic foot bridges over Bent Brook and a stone bridge over Tischer Creek; and constructing a water reservoir near the creek above London Road that was used to provide water for the greenhouses, gardens, and lawn.

After Chester died in 1916, Clara—who enjoyed privacy—made the grounds less formal by allowing trees and brush to grow relatively unchecked, consequently transforming the estate by placing it in a more lush setting.

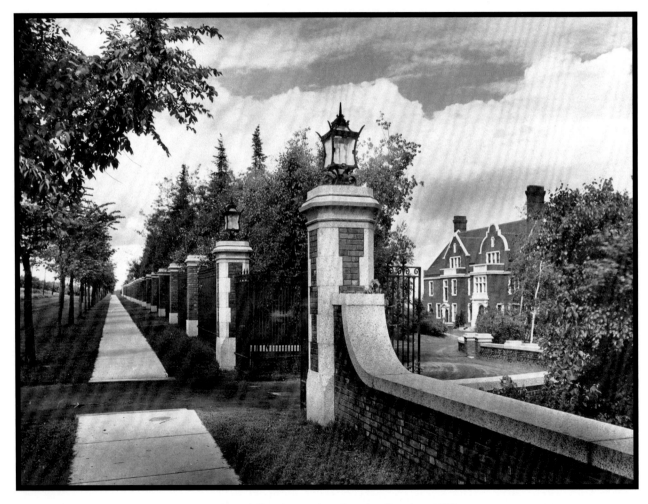

The view of Glensheen along London Road, c. 1909.

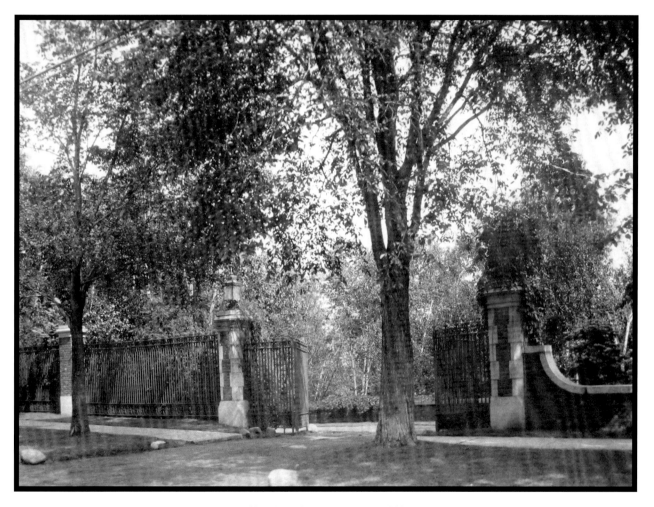

Glensheen's west gate, c. 1930.

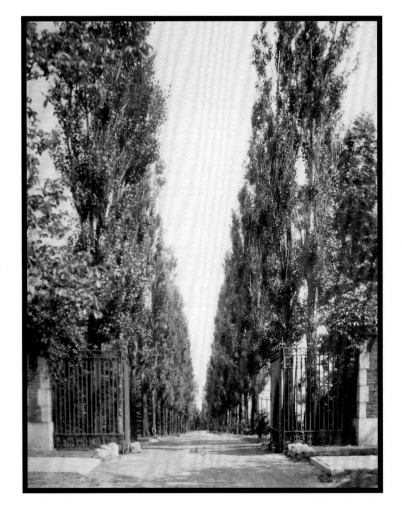

Looking south down the drive toward Lake Superior from the estate's east gate, date unknown (likely between 1909 and 1914).

This entrance is rarely used today, as visitors typically enter Glensheen via a parking lot on former pasture land to the east.

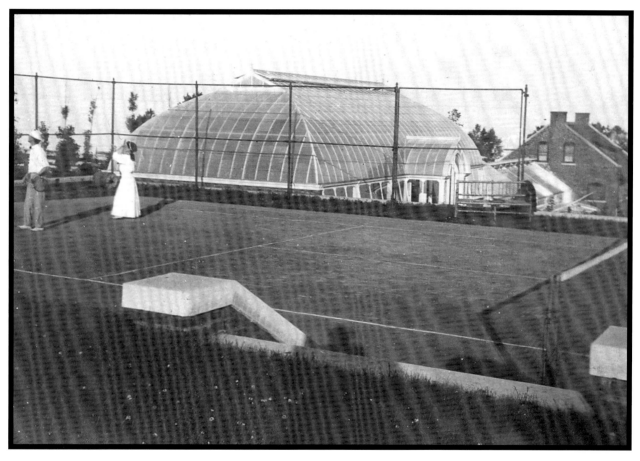

The tennis court, found just west of the driveway, year unknown (likely before 1920).
The unidentified players are probably Congdon family members or close friends.

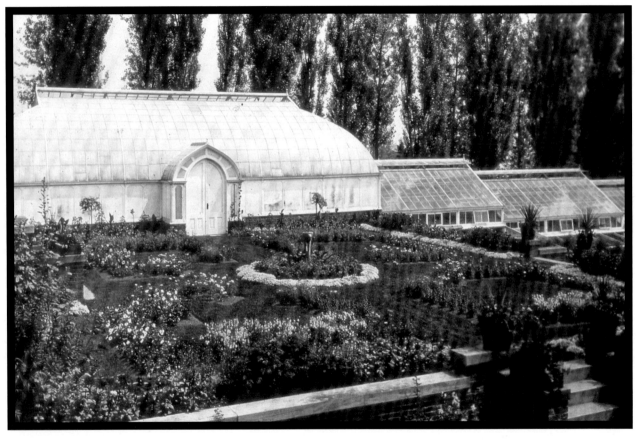

The flower garden and greenhouses, 1910. Glensheen originally had four greenhouses; the largest was the palm house.

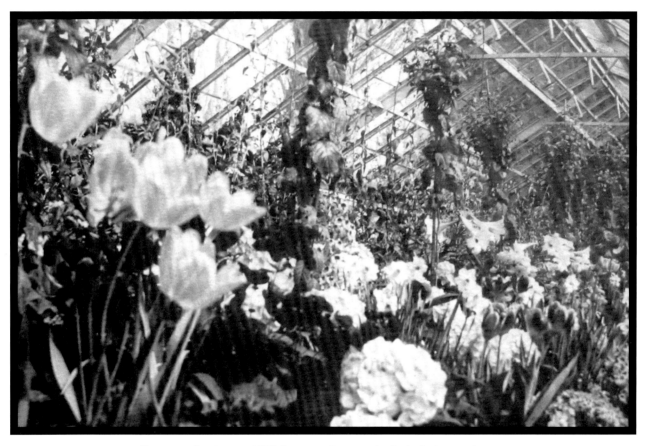

The carnation house, 1925; the greenhouses also included a rose house.

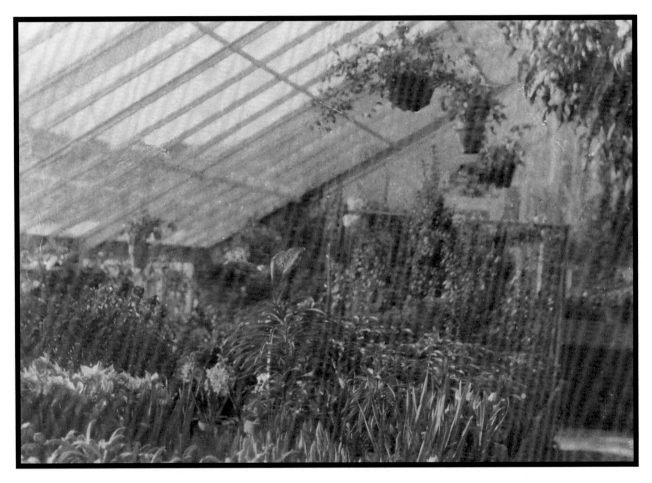

The general growing house, 1925. All of the greenhouses were removed in 1971.

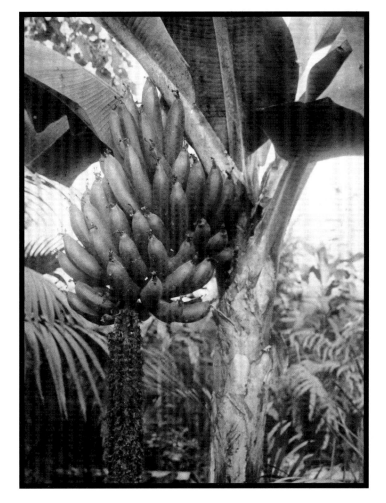

Glensheen was fairly self-sustaining: the Congdons owned dairy cows for milk and butter, a vegetable garden... ...provided fresh produce, and the palm house included a banana plant, as seen in 1925.

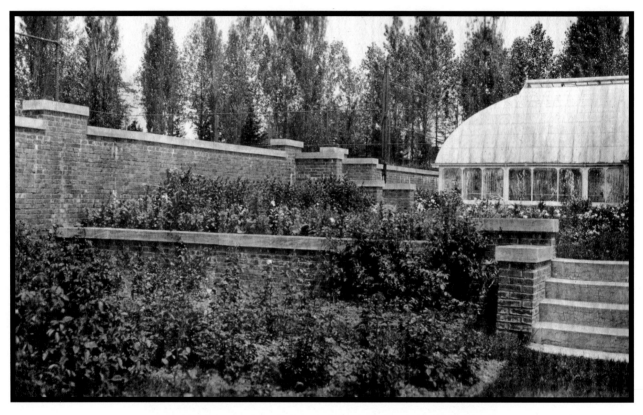

The flower garden just west of the palm house in 1918.

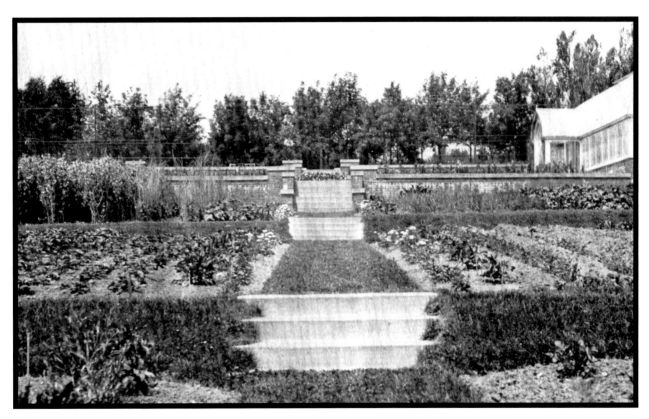

The vegetable garden (front) and flower garden, 1918.

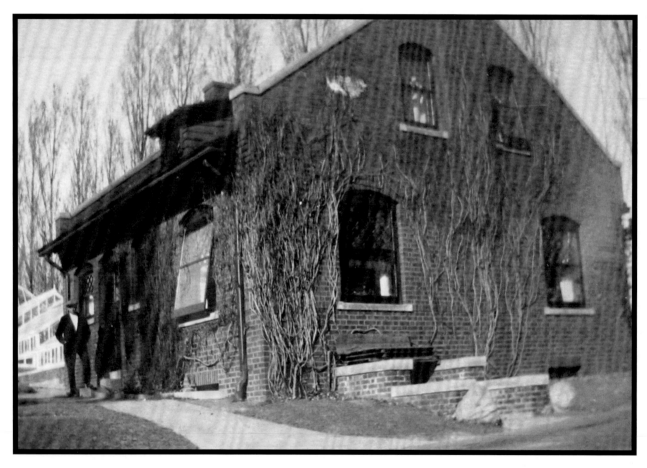

Gardener George Wyness standing next to the gardener's cottage sometime before 1927.

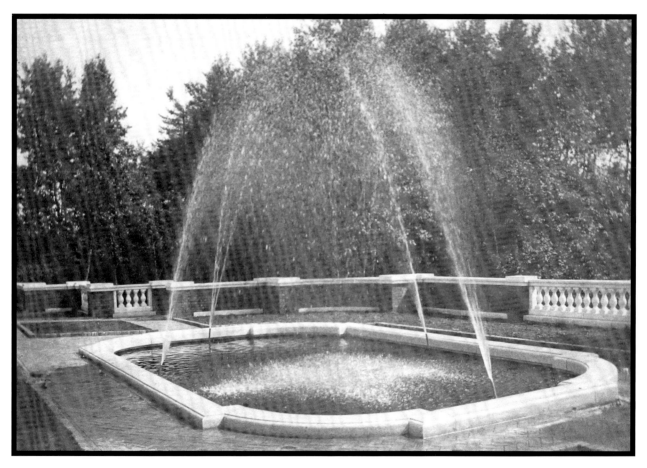

The formal garden's original 1908 fountain was simply four jets of water sprayed from the sides of the pool.

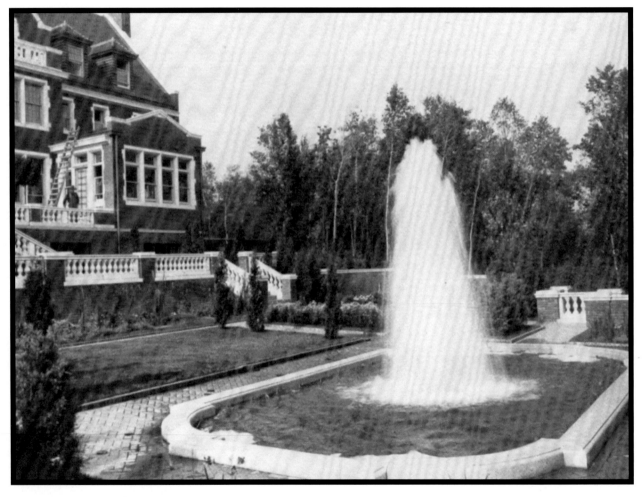

The Congdons replaced the original water jets with a centrally located spout sometime between 1909 and 1911.

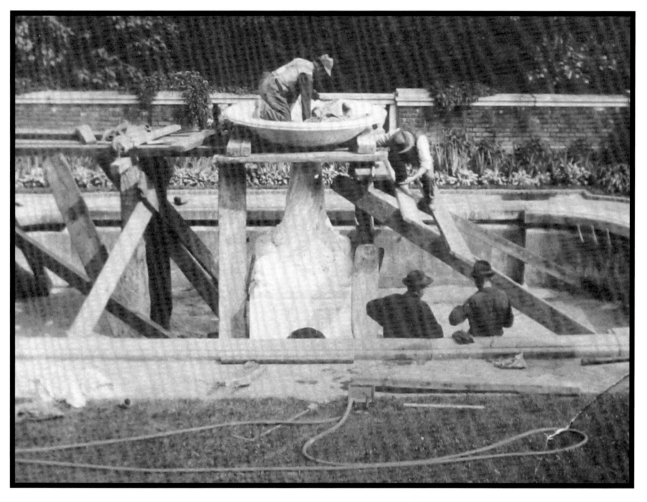

Duluth's master stone carver George Thrana created the current fountain, shown here being installed in 1913.

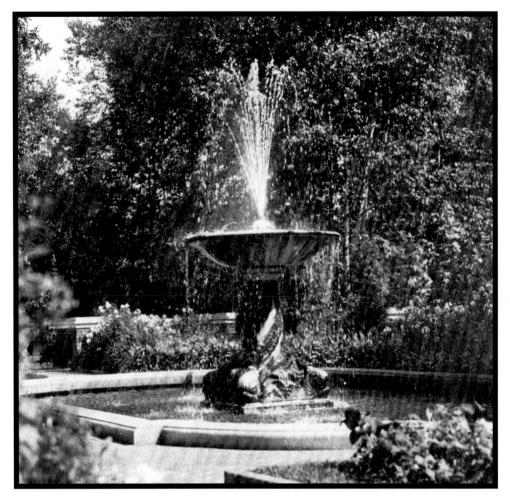

The Thrana fountain at Glensheen, c. 1918.

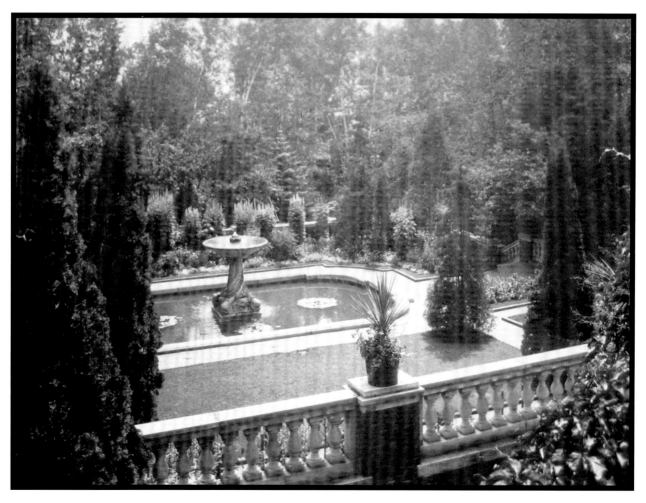

The Thrana fountain in Glensheen's formal garden, 1930.

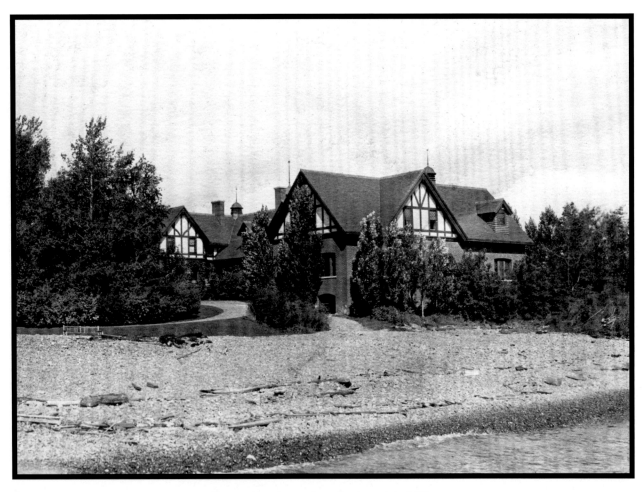

The carriage house from the beach in 1918.

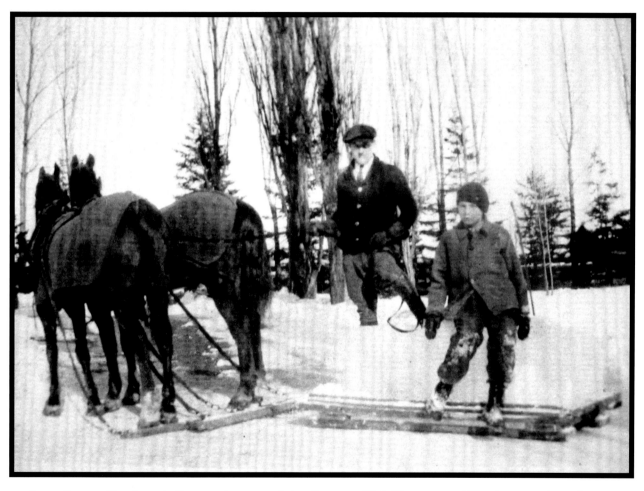

James Roper—Glensheen butler, coachman, and chauffeur—and Bob Wyness, son of Glensheen gardener George Wyness (and later gardener himself), use two of the Congdons' horses to haul ice cut from Lake Superior in the 1920s.

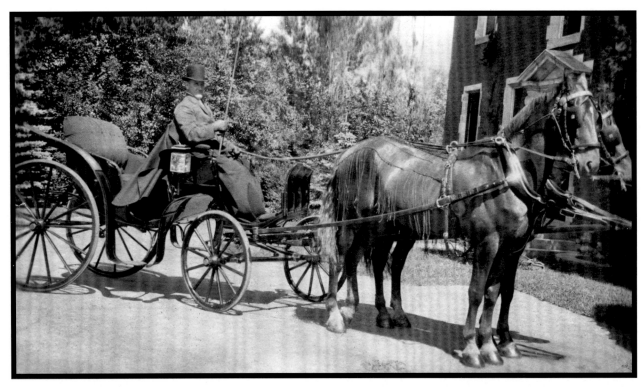

James Roper in the driver's seat of one of the Congdons' many carriages, c. 1910. The family owned a two- to four-passenger Rockaway Depot Wagon, a Studebaker Mountain Wagon, and several carriages made by J. B. Brewster, who later made automobile chassis for Rolls Royce.

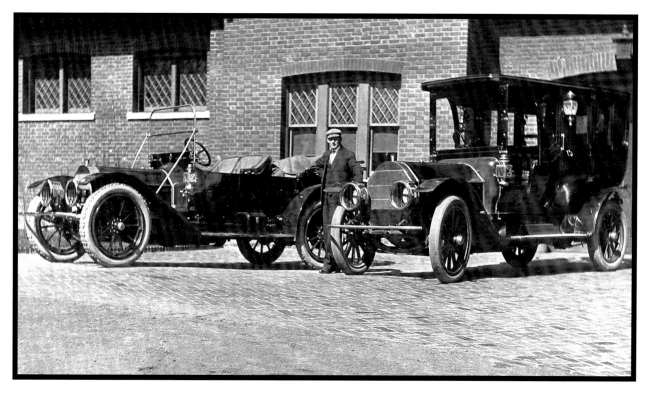

Roper with two of the Congdons' cars in front of the carriage house, c. 1925. The Congdons owned many carriages and several automobiles, including early vehicles from the Marmon Motor Car Company, two Pierce Arrows, a Cadillac, and an early electric car that was controlled with a steering stick instead of a wheel.

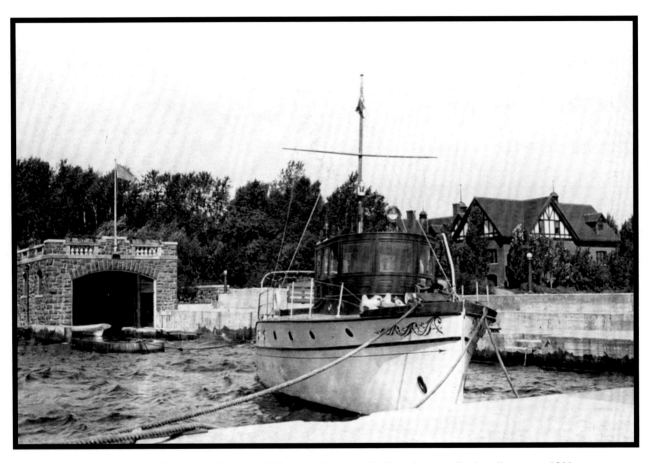

The family yacht *Hesperia* (Clara's middle name) moored to the pier near the boathouse, c. 1911.

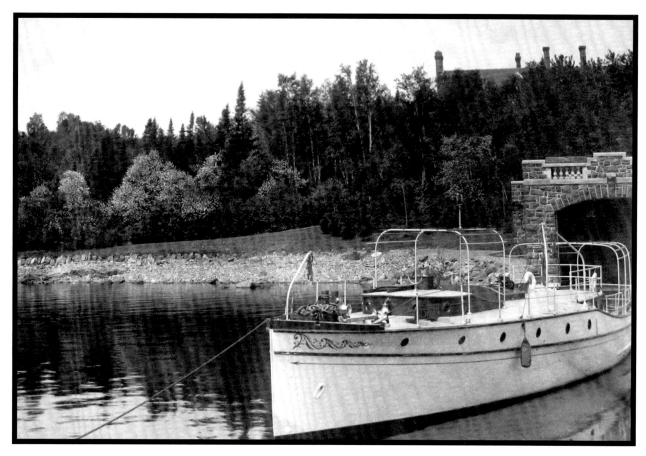

The *Hesperia* before the summer of 1916, when the vessel was destroyed by a fire started by a refuelling accident.

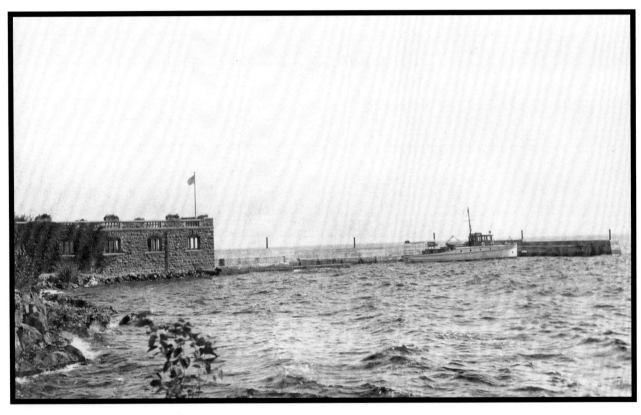

This view of the *Hesperia* and boathouse, captured between 1911 and 1916, shows the L-Shaped pier.

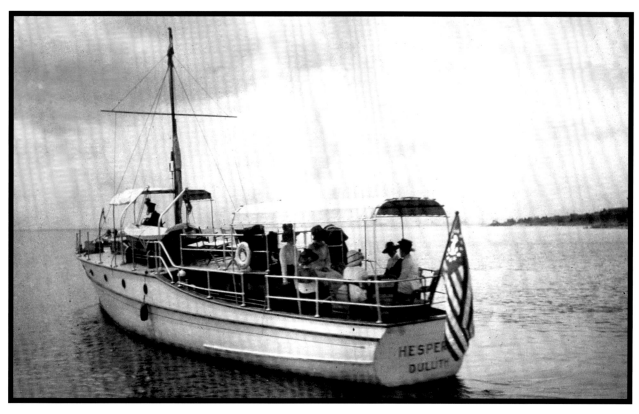

The Congdons and friends enjoy a Lake Superior cruise sometime between 1911 and 1916.

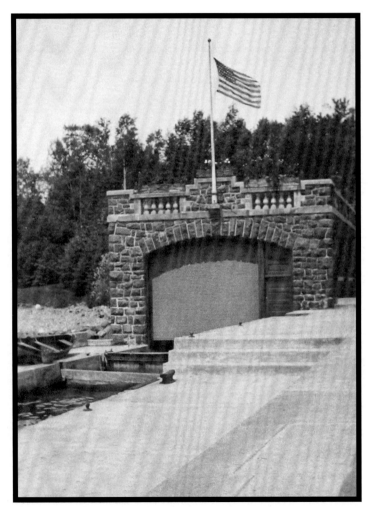

A close-up of the boathouse, c. 1910, showing the door—long gone today—that once protected the *Hesperia* and other watercraft.

The top of the boathouse was tiled and strung with lights, creating an outdoor dance floor for events such as Robert's 1923 wedding.

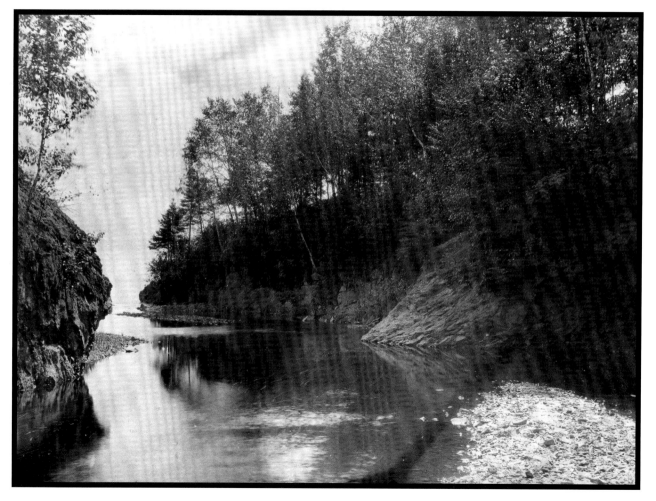

Looking south toward the mouth of Tischer Creek, c. 1909.

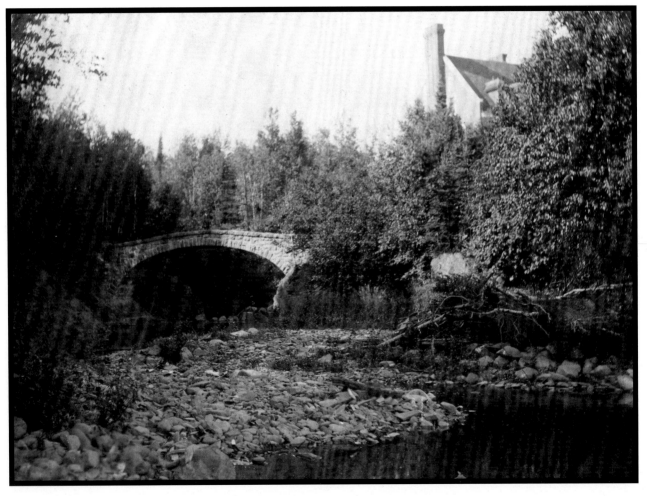

Glensheen's stone-arch bridge over Tischer Creek, c. 1909.

Along Tischer Creek below the west side of the main house, 1930. Note the staircase leading to the creek.

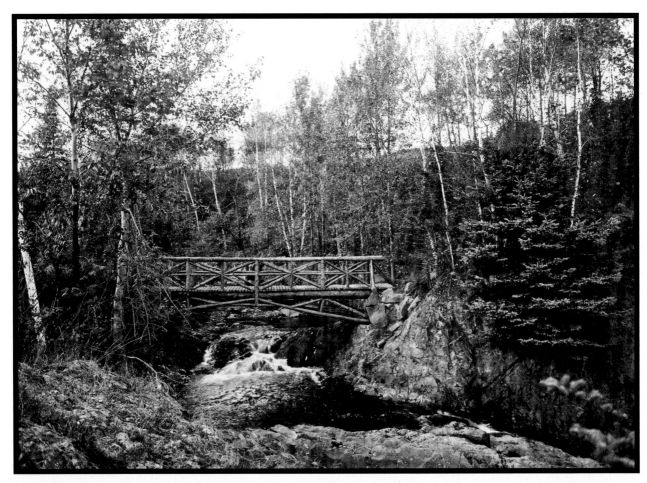

This rustic bridge, photographed in 1910, traversed Tischer Creek on the Congdon property below London Road.
Several similar bridges spanned the creek above London Road and Bent Brook on the estate proper.

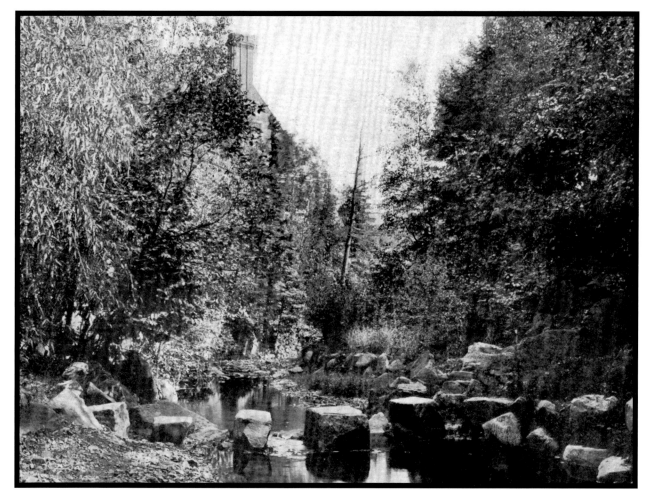

Facing south along Tischer Creek, likely 1910. This image was used to create a postcard mistakenly labelled "Chester Park."

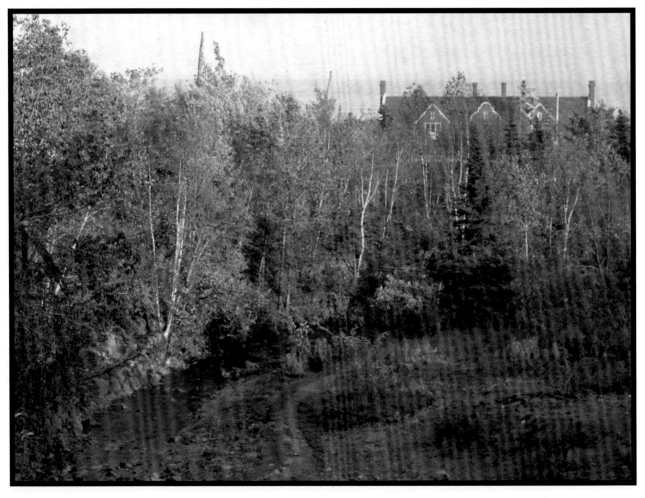

Facing south along Tischer Creek above London Road, c. 1909.

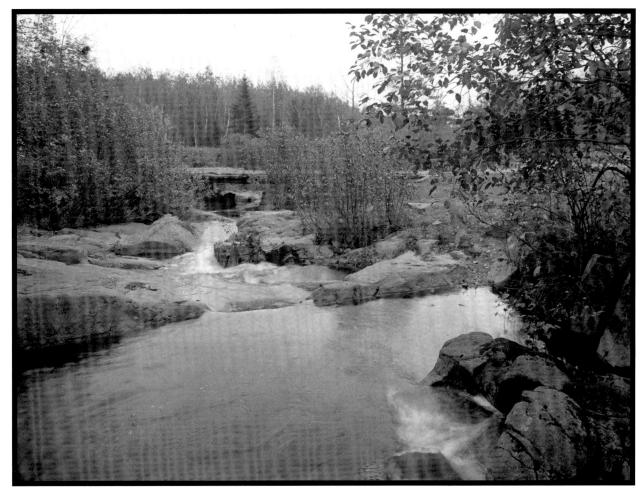

Tischer Creek above London Road facing south, c. 1909; the street in the background is Greysolon Road.

Tischer Creek above London Road facing north, c. 1909; the wooden bridge was part of Greysolon Road.

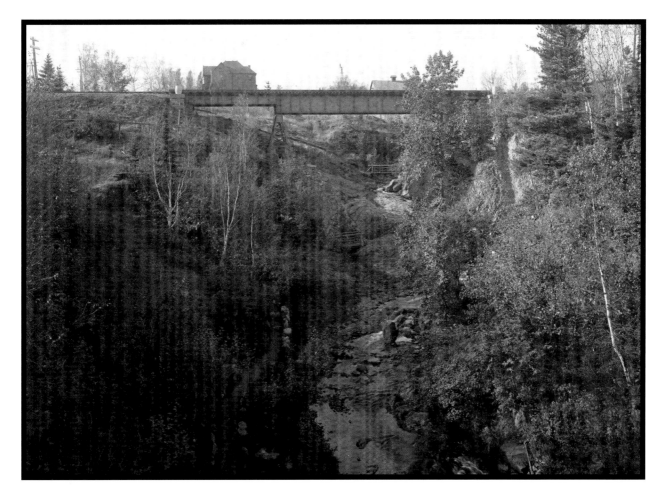

The DM&IR Railroad bridge crossing Tischer Creek above London Road, c. 1909.

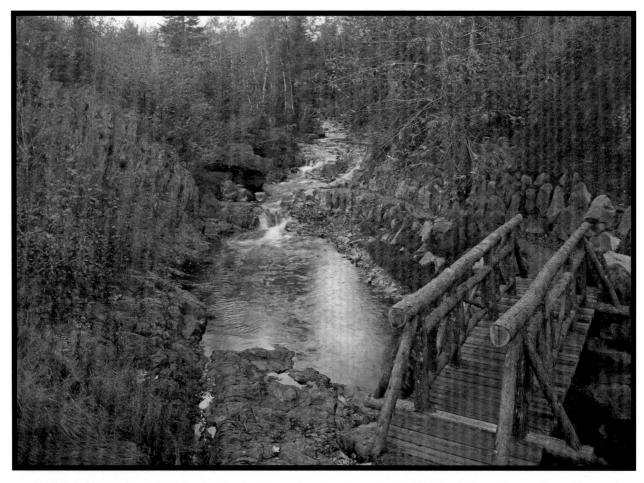

This rustic bridge over Tischer Creek, c. 1909, was located beneath the DM&IR bridge on the previous page.

Postcard of Congdon Park, c. 1911.

CONGDON PARK

The Congdons' grand plan for Glensheen included creating a public park along the banks of Tischer Creek from the estate's border upstream to Vermilion Road. According to Duluth parks historian Nancy Nelson, much of this land was owned by Congdon's East Duluth Land Company. The firm offered to donate its land and cover the cost of acquiring additional property.

Congdon's gesture had a practical purpose. The creek served as a sewer for neighborhoods further upstream. Congdon wanted to use the creek's water to supply Glensheen, and his offer was contingent on the city redirecting sewage into a holding tank.

The Park Board accepted Congdon's offer in August 1905. By the end of 1907, the Board had acquired about thirty acres of undeveloped land along the creek. On March 2, 1908, it passed the following resolution: "Resolved, that this Board, for, and on behalf of the city, hereby extends a hearty vote of thanks to Mr. C. A. Congdon for the very generous donation of the Tischer's Creek park grounds; a very desirable acquisition to the city's holding in that particular, and be it further resolved that the said grounds be, and the same hereby are, named and designated 'Congdon Park.'"

Congdon's generosity continued when he offered the services of landscape architects Leavitt and Morell, who had worked on Glensheen (see page 75). Leavitt's sketches included a "Swiss chalet...for shelter, for basket lunches, and a place for mothers and nurses to sit while they watch the children play...." Despite the plan, the city made few improvements to the property. By 1911 it had developed the west side of the park, creating a twenty-foot-wide roadway, an eight-foot-wide bridle path, rustic bridges, stone stairs, and a footpath along the creek's edge. But the chalet was never built, and the east side was left relatively untouched.

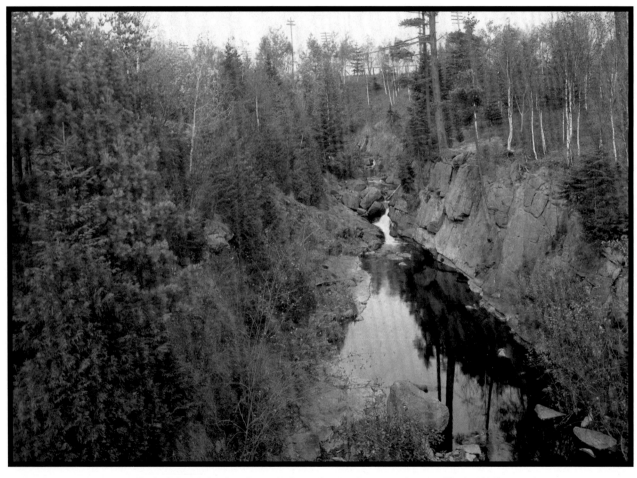

Tischer Creek flowing through Congdon Park, year unknown (likely 1909).

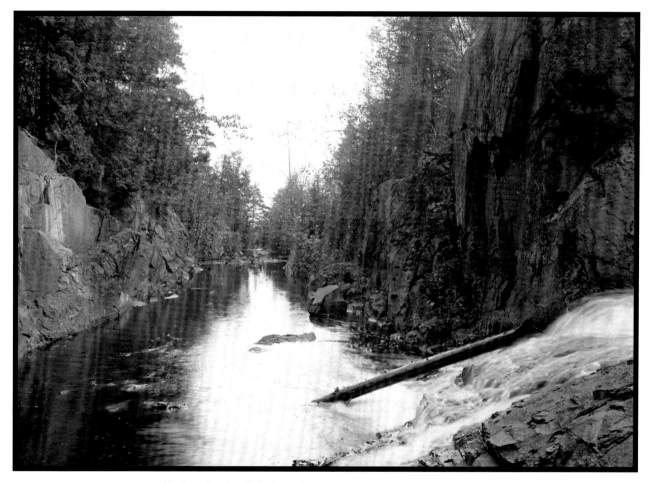

Tischer Creek within Congdon Park, date unknown (likely 1909).

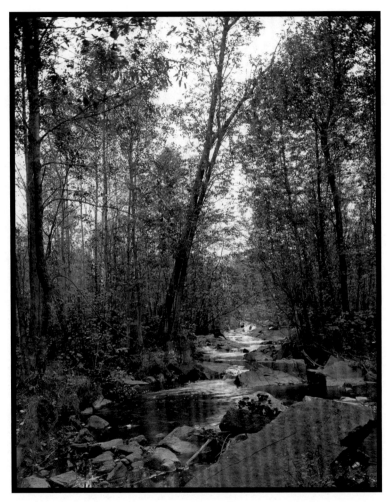

Tischer Creek within Congdon Park, date unknown (likely 1909).

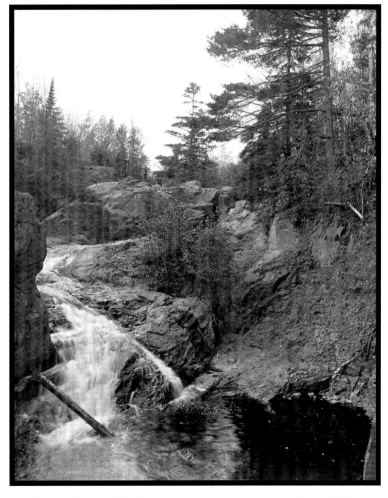

Tischer Creek within Congdon Park, date unknown (likely 1909).

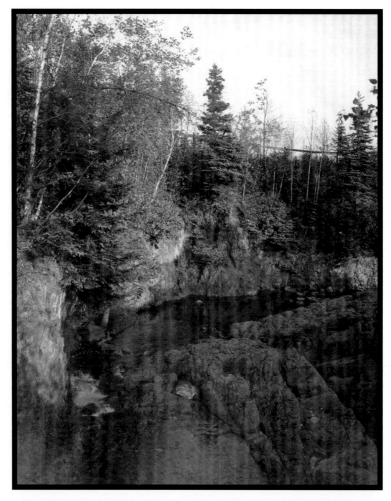

Tischer Creek within Congdon Park, date unknown (likely 1909).

APPENDIX

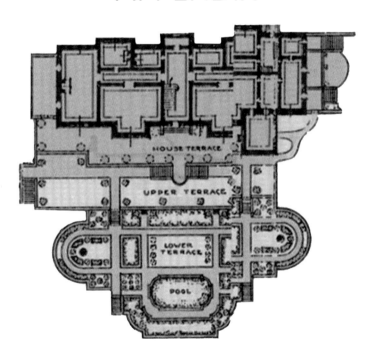

GLENSHEEN'S FIRST FLOOR

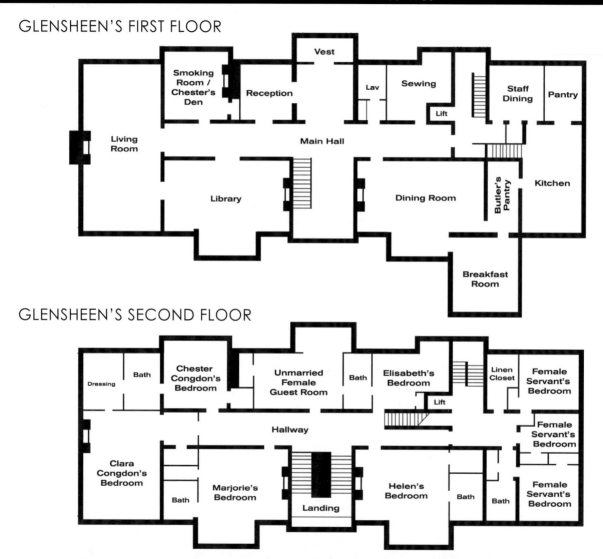

GLENSHEEN'S SECOND FLOOR

GLENSHEEN'S THIRD FLOOR

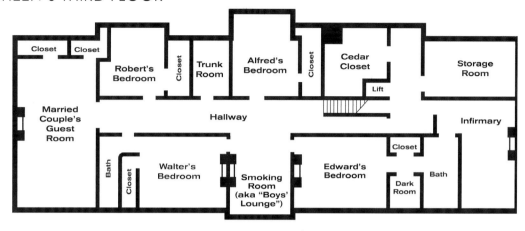

GLENSHEEN'S LOWER LEVEL

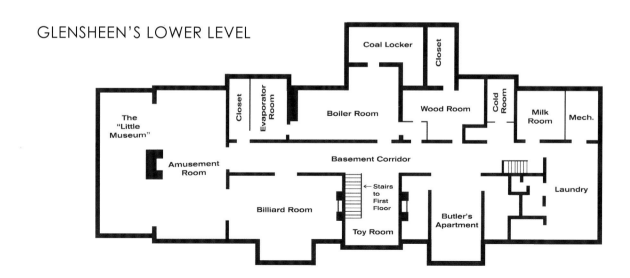

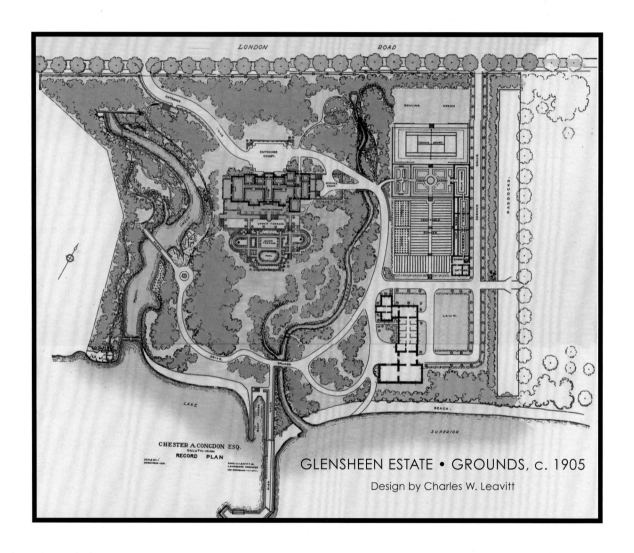

GLENSHEEN ESTATE • GROUNDS, c. 1905

Design by Charles W. Leavitt

BIBLIOGRAPHY

Chamberlain, Carol. "Glensheen House & Grounds Tour." (Unpublished manuscript). Duluth, Minn.: Glensheen/University of Minnesota Duluth, 1990.

Feichtinger, Gail, et. al. *Will to Murder: The True Story behind the Crimes and Trials Surrounding the Killings at Glensheen*, 4th Edition. Duluth, Minn.: Zenith City Press, 2013.

Fourie, Ada. *Their Roots Run Deep*. Duluth, Minn.: Glensheen/University of Minnesota Duluth, n.d.

Hartman, Daniel F. "Glensheen Grounds Tour." (Unpublished manuscript). Duluth, Minn.: Glensheen Historic Estate, 2005.

Hoover, Roy. *A Lake Superior Lawyer*. Castro Valley, Calif.: Kutenai Press, 2013.

Johnston, Clarence H. "A Residence in Duluth." *Western Architecture Magazine*. April 1910.

Lane, Michael. *Glensheen: The Construction Years*. Duluth, Minn.: Glensheen/University of Minnesota Duluth, n.d.

Nelson, Nancy. "Congdon Park: A 'Most Picturesque Sylvan District,'" *Zenith City Online*. www.zenithcity.com. June 24, 2013.

Soetebier, Virginia. *Footnote to History*. Duluth, Minn.: Glensheen/University of Minnesota Duluth, n.d.

Vanderwerp, Mary. "National Register of Historic Places Registration." Duluth, Minn.: St. Louis County Historical Society, 1991.

IMAGE CREDITS

Photograph of Clarence Johnston, page 3, courtesy of the Minnesota Historical Society.

Photograph of Glensheen's south façade, page 25, courtesy of the Duluth Public Library.

Photograph of Charles Leavitt, page 75, courtesy of the Cultural Landscape Foundation.

Photograph of stepping stones on Tischer Creek, page 105, courtesy of the Duluth Public Library.

All other photographs courtesy of Glensheen Historical Estate.

Image of postcard of Glensheen, page iv, courtesy of Zenith City Press.

Image of blueprints of Glensheen's north elevation, page 21, courtesy of Glensheen Historical Estate.

Image of advertisement for the William A. French Furniture Company, page 33, courtesy of Zenith City Press.

Image of postcard of Congdon Park, page 111, courtesy of Zenith City Press.

Image of Charles Leavitt's plan for the estate grounds, page 120, courtesy of Glensheen Historic Estate.

Diagrams of Glensheen's floor plans on pages 118 and 119 courtesy of Zenith City Press.

See the foreword on page v for further information about the photographs in this book.